Pet Photography
For Fun

Let's Have Fun Photographing Dogs, Cats, Horses, Alpacas, Llamas and Everything Else!

Written and Photographed by Susan Ley

with photographic contributions by Marsha Hobert

WATER DOGS
PUBLISHING

Water Dogs Publishing
4265 B Marin Woods
Port Clinton, Ohio 43452
(614) 565-4255
©2011 by Susan Ley
www.susanleyphotography.com

EDITORS

Sue Beal
Cheryl Dal Porto
Hal Quanbeck
Dr. Robert Schwenk

●

COVER & INTERIOR DESIGN

Marsha Hobert
Hobert, Ltd.

●

SPECIAL PHOTOGRAPHY Credits

John Caputo
p. 44, 117 & 122

Marsha Hobert
p. ii,6,7,11,16,19,20,22,24,
27,28,30,34,42,43,45,
50,54,56,61,65,67,74,80,
82,88,94,98,102,103,104,
107,122,123,124

Tammy Shanahan
p. 68 & 106

Library of Congress Control Number
2011925885

ISBN: 978-0-9752876-1-3

Additional copies may be ordered at
www.WaterDogsPublishing.com

TABLE OF CONTENTS

EIGHT QUICK TIPS TO IMPROVE YOUR ANIMAL PHOTOGRAPHY

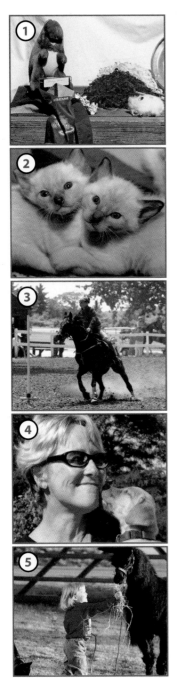

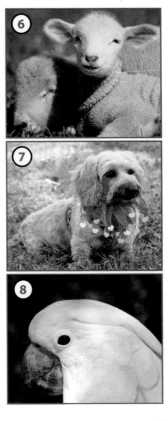

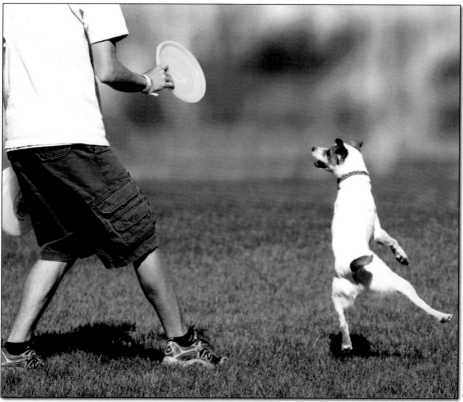

© Marsha Hobert

and the best tip of all...relax and have fun!

The first step is to start at your own
level, so follow the practice tips for
beginner, intermediate and advanced at
the end of each chapter.

\mathcal{G}etting there isn't half the fun — it's all the fun! – Robert Townsend

ARE WE HAVING FUN YET?

This book is user-friendly and fun … it's all about relaxing and being entertained while you learn to photograph animals.

That's because *whatever you are feeling while you are making pictures will transfer into the photograph*.

So if your dog jumps into the pool and you rush to grab your camera, but darn – you are leaving in five minutes to take Aunt Harriet shopping, then your mind is already at the mall and your photography is going to suffer.

On the other hand, if you slow down and concentrate on staying in the present moment when you photograph, you will *feel* what is in front of the lens and we will also feel it when we view the photograph.

So start relaxing right now. Smile. Take a deep breath. See? Now you are able to appreciate life fully with one of the best tools to capture it all … your camera!

If you are an animal lover, what could be more enjoyable than working with your favorite animal, and appreciating that animal enough to try to capture its essence right now?

Let's begin!

Magic is believing in yourself. If you can do that, you can make anything happen. – Goethe

GREAT PHOTOGRAPHY IS MAGIC...

But, just like Harry Potter, you have to go to school to learn how to cast a spell with your wand, or in this case, with your camera.

Start by studying your camera manual. That's the little book that came with your camera that you'll find wadded up in the back of your filing cabinet.

Take it out, dust it off and put it in your camera bag ... after you have read it from cover to cover and studied it. You need to understand how to make your camera work so you can forget about how to make your camera work when you shoot.

Photographing animals is a challenge because they move. You are going to lose a lot of great shots if you are standing there trying to figure out which control to adjust while the horses are hoofing it over the hill.

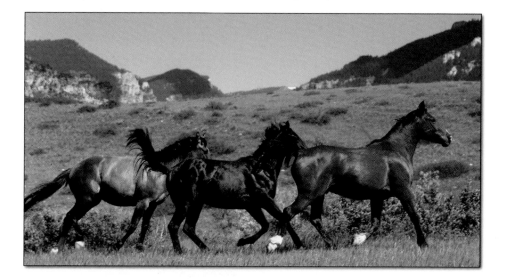

If you're thinking, "Hey, I already know everything there is to know about my camera," so much the better. But review it anyway. I will bet my antique Brownie camera that you'll learn some things about your camera you didn't know.

Once you complete your manual review, you will be ready to start making unique animal images that will literally jump off the glossy page. That's where *your* magic will begin.

t's kind of fun to do the impossible. – Walt Disney

ANIMAL PHOTOGRAPHERS DON'T DO FASHION SHOOTS!

Photographing animals takes equipment to help you get "the shot." One way to avoid stress equal to an air traffic controller in the middle of a Miami snowstorm, is to make sure you have everything you need before you begin to shoot. Here is my "must have" list for photographing animals.

▲ Digital Camera

Digital cameras are perfect for animal photography, where their strength, the ability to instantly see if you captured the action, make them an awesome tool.

Be sure to invest in one of the newer digital cameras if you want the best performance—older digitals have excessive shutter delay problems that produce unacceptable results. This doesn't mean you have to buy an expensive digital, but it does mean you want the latest model in your price range. New cameras come on the market constantly. Check with the web sites listed in the Appendix for the latest information on what to buy.

▲ Manual

What's the most important piece of equipment you own? Your manual of course! Everything you need to know about *your* camera is there. Read it from cover to cover and keep it in your camera bag for quick reference.

▲ Digital Film

Images are captured on a CCD (charge coupled device) or CMOS (complementary metal oxide semicon-ductor), then stored on a memory card. The memory card is your "digital film." Buy two. Having an extra memory card is important if you

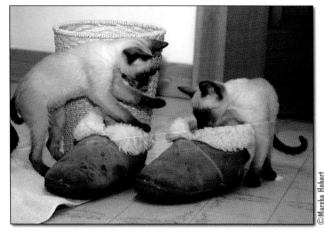

don't want to run out of storage space in the middle of a shoot.

Even with two memory cards, it doesn't take much math to figure out that you are going to be saving a bundle on film. The model and make of your camera determine which type of memory card you need. And to find that out, you … **READ YOUR MANUAL!**

▲ Extra Batteries

Digital cameras won't work without a battery, so always carry a spare.

▲ Props

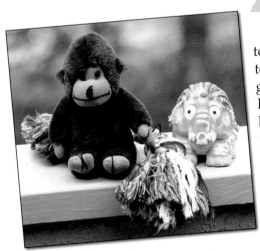

Collect props like these toys to help make the ears of the most terrible terrier you've ever photo-graphed stand straight up. Aunt Harriet's wig might also work, but then the onlookers will think you've gone a bit bonkers. But, it's a good thought. Whatever works to make the animal you are photographing watch you with rapt attention will translate into some wonderful expres-sions which will translate into some dynamite photos.

Props are right up there with the camera in terms of what you need for great animal photography. The camera is going to record the image, but the prop is the key. Without props, you are just hangin' around waiting for your Rottweiler and your African hedgehog to do something. But with props, you become the artist—the maestro—the creator! (Or perhaps … the funeral director?)

Keep the props under cover so when the ten-second attention span of Lily's pony disappears, presto, you pull out another prop and shoot like heck while the ears are up.

When an animal's ears are up and forward, they look happy and alert, much the way humans look with a smile. Animal ears that are flattened and back indicate stress, much the way humans look with a frown.

You'll find more about the importance of animal photographs with the ears up on page 99. It is one of my pet peeves, and something you will never be guilty of once you finish this book.

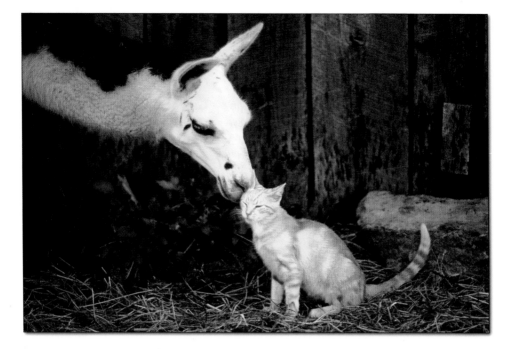

▲ Flash

Almost all modern cameras have a built-in flash and you need one for good animal photographs, so you won't miss the chance to photograph Sally telling Tabby a secret behind the barn.

The flash range is usually about 10 to 12 feet, but to know what your flash subject-to-distance range is, get out your trusty manual and look up the distance range for your flash at each ISO (International Standards Organization) setting. (See pages 86 and 109.)

If you are an advanced photographer, you may want to invest in an external flash as well.

▲ Skylight or UV (Ultra-Violet) Filter For Every Lens You Own

If you are shooting with an advanced SLR (single lens-reflex) digital, each lens you use needs a filter to reduce bluishness and haze in your outdoor shots, and to protect your lens. If you scratch your $15 skylight filter, throw it away and buy a new one. If you scratch your $300 lens, throw it away and buy a new one. You get the picture (and by the way, you won't get the picture with a scratched lens). You can read about the differences in these two filters in the Glossary.

▲ Lens Hood

Lens hoods reduce or eliminate lens flare (stray light that creeps into your lens when shooting outdoors—which is where we are shooting 99% of the time).

Actually, if you're shooting animals indoors all the time, you are probably better off concentrating on new subject matter. How about colorful wooden fish?

Lens hoods make you look professional, which is the reason most pros keep them on all the time, even indoors. Just kidding. Pros know their lens has more protection with the hood on.

▲ Polarizers

Polarizers produce rich, saturated colors, especially green (grass and trees) and blue (the sky). Since most animals aren't multi-colored, leave your polarizer off when you make animal portraits.

However, you want to leave it on if you are making an image which includes water. Polarizers reduce glare, so if you are shooting the polar bear who likes to swim in your pool, keep the polarizer on.

Also use it if you are shooting a field of animals or a landscape where the color of the scene is more important than the animal's true color.

With a polarizer, be sure to buy the best glass you can afford—don't skimp. (Say "glass" when you're on safari and you want to sound really professional as in, "I brought along some great glass.")

▲ Small Notebook And Pen

You want to improve, so keep your notebook handy and record any information you need to remember. For example, locations with great backgrounds, the light when you made a stunning image, or pet behavior you want to try and capture again. This is especially important at shows, where you may not remember what worked well the last time you made images at that location. Write it down!

▲ Sunscreen

We're animal photographers. We're outside in the sun, not hidden in the nook of a tree waiting for worms. Put on lots of sunscreen.

But be careful. Sunscreen and insect repellents can damage your camera by eating away at the plastic. Wash it off your hands before you begin to shoot.

▲ Hat With A Visor

A visor will shield your eyes while you compose, and it's a wonderful prop when you need one in a hurry. You can yank it off, throw it in the air, yell "yee haw" and shoot like crazy before it comes down and bonks you on the head.

▲ Pants With Deep Pockets

Animal photography isn't glamorous, so wear your old clothing. Fashion photographers have it easy – air conditioned studios, perfect backgrounds, gorgeous models. Who would want that job, when you can be out in a field photographing a pouting ostrich?

Buy some roomy pants with big pockets. They'll work for carrying most of what you need to access in a hurry – aspirin, tranquilizers, BenGay®. Shout it out … "real photographers don't do fashion shoots!"

Last of all, you need sturdy shoes. Otherwise, be prepared to look very unprofessional when you fall flat on your face in pursuit of the perfect image.

▲ Cleaning Kit

We're usually working outside and that means dust, dirt, wind, rain, snow and gritty fingers beating up our equipment. Smudges and spots on your lens will totally ruin whatever image you were trying to make, so invest in a cleaning kit and use it.

▲ Is This All The Equipment You Will Need?

You bet! We're not lugging along three cameras, five camera bags, 15 filters and 20 lenses, looking smug because we have more equipment than a zebra has stripes. We want to concentrate on our subject matter, not our equipment.

Great photography is a combination of what the eye sees and what the photographer feels inside. Getting your feeling into a two-dimensional photograph takes concentration, practice and dedication – but it rarely takes more equipment. You will soon find that a lot of extra equipment will slow you down and hinder your ability to think quickly.

C'mon. Leave all that extra stuff in the barrel. We are going to master only the equipment we need. It will be enough!

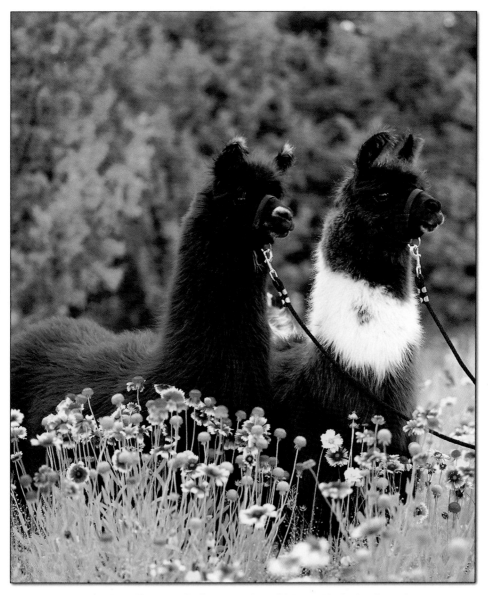

In this portrait of two llamas, a flash was used to add "pop" (look closely at the eye area where you can see the reflection of the flash). A careful search was made to find the perfect setting, and a long lens set at f5.6 was utilized to isolate the subjects.

*\mathcal{I} never did a day's work in my life.
It was all fun. – Thomas Edison*

SOMETIMES COMPUTERS ARE CRANKY

Sometimes my computer is cranky and I want my pet elephant to eat it. I bet there are days when you feel that way too. In fact, you might have decided not to buy a digital camera because you don't want to learn a lot of complicated computer stuff.

Well remember, *you can buy a digital camera and never touch a computer.* Just click away, and when you have filled up your memory card, drop it off at a photo lab and let them do the editing and printing. Hey, that works for me!

On the other hand, if you want to go whole hog, you can buy a photo software program and learn how to crop, sharpen, brighten, darken, remove, change or make Aunt Harriet into Uncle Harvey.

The point is, with digital, *you* get to choose. You can drop off your memory card and let someone else do the printing and editing, or you can learn to do it all yourself.

Whatever you decide, keep the emphasis on making creative wonderful photographs.

Advanced

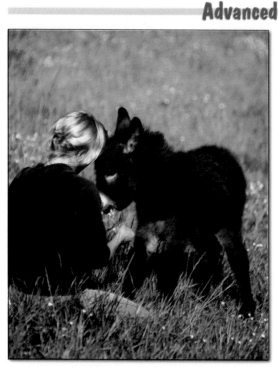

The focus of this book is how to take great animal images. But you happen to *like* computers. So go to the Appendix where you'll find a list of books and web sites with enough information on manipulating and printing your digital files to make you into a real wiz in digital photography.

But remember. Before you can manipulate your photos, you have to learn the basics of good animal photography. That is key, no matter what you do with them later.

A nimals are such agreeable friends – they ask no questions, they pass no criticisms. – George Eliot

It's Time For Ice Cream!

Light is one of those things you can't control when you are photographing animals, but you can control the time of day when you photograph. This is so important that your first assignment is to make a list of things to do when the light isn't right. That way you won't make the mistake of trying to photograph anyway.

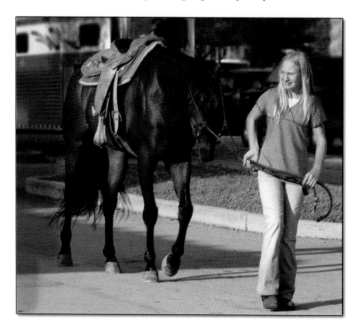

Your list might include, "get an ice cream cone," or perhaps "go riding instead."

The point is that any time the sun is shining is not necessarily a good time to photograph. In fact, high overhead sun between ten and three is too harsh for good close-up photography.

But there are still plenty of hours in the day to photograph. Take a look at these images and figure out where the light is coming from in each one. Then ask yourself if it's time to photograph or time to go get ice cream?

●→ Top Light:

The sunlight is directly overhead, casting shadows on the subjects.

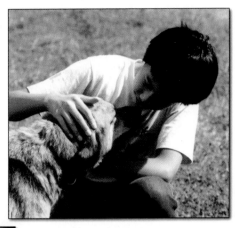

←● Front Light:

The sun is behind the photographer, illuminating the subject. This light can be wonderful early in the morning and late in the afternoon. Landscape photographers refer to this time as the "magic hours" because the color of the light can be so rich.

●→ Side Light:

The light is slanted, illuminating one side of the dog's face while the other side is in shadow.

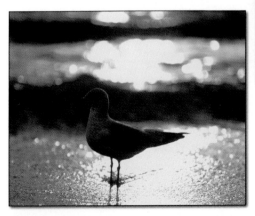

←● Back Light:

The sun is behind the bird, creating a halo effect.

●→ Shade and Sun:

The shade is casting shadows while the sun is illuminating the dog so his hair is too dark and too light (patchy) at the same time.

←● Diffused Light:

It is impossible to tell where the light is coming from because the sun is behind the clouds. This eliminates the direction of the light, making it excellent for close-up work.

©Marsha Hobert

Can you see that the best time of day for good natural light is early in the morning or late in the afternoon when the light is softer? That way you avoid the glare of noonday sun when the shadows are harsh and unflattering on animals and people.

This will leave a lot of time free to eat ice cream! On cloudy days when you don't have difficult exposure problems, you can grab your dog with his favorite ball, and photograph like crazy until you lose the light.

Go outside and study the light through your viewfinder or LCD screen at different times of the day, watching to see how the light falls on the animals and on the locations you think will make the best background for your pictures.

Just look. Don't push the shutter button, because you need to concentrate on thinking about what you want to capture. *The planning is an integral part of the process.*

Do this exercise early in the morning, at midday and late in the afternoon. On a bright sunny day, watch how the shadows fall on the landscape, buildings and animals, and *how the shadows shift during the day.*

Do the same exercise on a cloudy day.

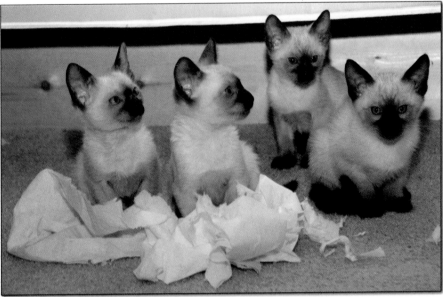

Keep your camera handy so you can capture those mischievous moments when your pets decide to play. Using flash inside to make great photographs like this one, is covered in Chapter 18.

Examine each photograph in the collage on page 22.

1. Where is the light? (front, back, side, diffuse)

2. What is the angle? (90 to 45 degrees)

3. How intense is it? (harsh sun to cloudy)

Advanced

1. Create portraits that combine good light with good background choices. (The light is perfect. You are ready to shoot your pet but he is in a spot with a cluttered background. Scout around for a better background that has the same great light.)

2. Take out your manual and study the section on setting your white balance. The camera is set for automatic white balance, but as an advanced photographer, you need to be able to go into the menu and change the white balance setting depending on the light. (See Chapter 13, page 78.)

Once you have a good understanding of all the variances in natural light, you'll be ready to use your flash in different lighting conditions to both correct lighting problems and add some "pop" to your outdoor photographs. (See Chapter 18, page 109.)

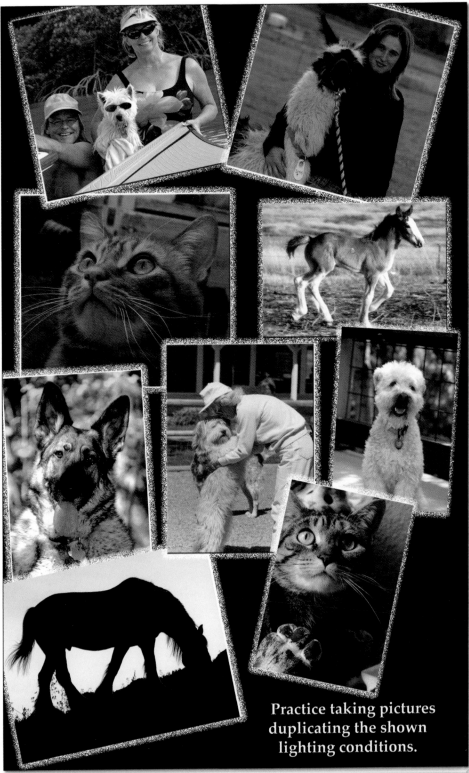

Practice taking pictures
duplicating the shown
lighting conditions.

\mathscr{T}he photographer must lie in wait and have a presentiment of what is about to happen." – Henri Cartier-Bresson

THE ORCA JUST ATE UNCLE HARVEY!

Before you can take a picture of the orca swallowing Uncle Harvey, you need to make sure your camera is set to take the photo at the highest resolution. Get out your manual and look for a chart somewhat like this:

Selecting An Image Size For Use

Image size	Usage guidelines
8M (3264x2448)	up to 11x17 print
5M (2592x1944)	up to 8x10 print
3M (2048x1536)	up to 5x7 print
2M (1632x1224)	up to 4x6 print

The M in the above chart stands for megapixels (millions of pixels), and shows how large you can print your photos. A bigger number means you can print a bigger (higher resolution) picture.

You skipped this chart in your manual, didn't you?

If you are a member of the *"Let's Have Fun Club,"* set your camera on low resolution and flip to Chapter 7. However, serious photographers should read on.

Every digital camera has a megapixel rating which represents the biggest picture it is capable of taking, and it is all about the math. Each photograph is made up of millions of tiny dots called pixels. Think of every dot (pixel) as a color recorded by the camera at the time of exposure. Millions of these dots, lined up side-by-side, both vertically and horizontally, represent your image. (They all blur together to the human eye.)

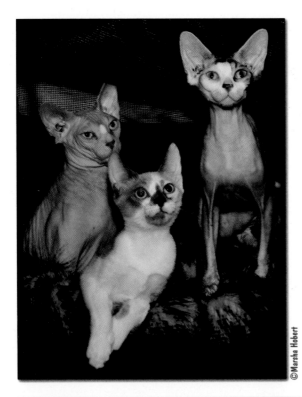

©Marsha Hobert

It's all about the math and size matters.

Bigger files = more pixels = bigger prints

Smaller files = fewer pixels = smaller prints

Since size matters, before you shoot, you must answer two questions:

1. What am I going to do with this photo?

2. What is the best setting for that use?

If you start by thinking about the end use of your photo, you'll begin to understand why size matters. Images made with

small megapixel settings will look fine for scrapbooks, photo albums, web sites, blogs or e-mail.

But if you like to print your photos extra-large, or you enjoy enlarging and re-cropping them, then you need the higher megapixel settings to get larger sized images.

Since you don't always know what your end use for an image will be, it's best to always keep your camera set at its highest resolution because size matters and bigger is better.

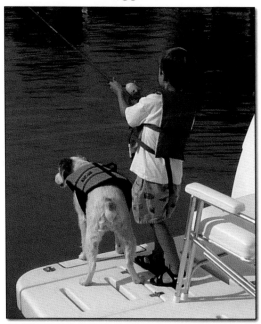

So now you realize that the photo you made of your son fishing in the Bahamas when the orca came swimming into the harbor ... the one you planned to send to *National Geographic* for the cover ... that one is toast. They can't use it because you didn't have your resolution on the highest setting.

Next time you will be prepared because right now you are going to put your resolution on its highest setting and leave it there.

Now, let's tackle file storage.

Your camera uses a memory card to store your images. The more storage the card has, the more images it can store and the more it costs! Plus the bigger you take your pictures the bigger the file size and the fewer you'll be able to fit on the memory card. And since we're into saving files at

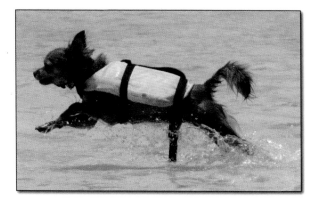

the highest resolution settings our camera can produce, we're going to need an extra card.

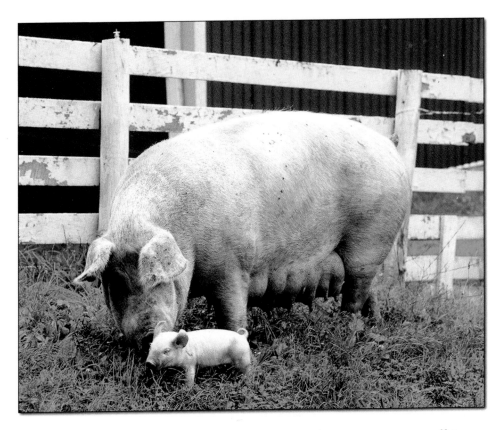

It makes sense, doesn't it? Plus, you just put in an emergency call to your computer guru, and begged him to stop by and explain this stuff.

Now, what about Aunt Harriet?

You're making images at your camera's highest resolution setting, but you also want to send some to Aunt Harriet in an email, and whoa, hold it! The files are huge. Her old computer can't handle files this big and they will load in so slowly that she'll get bored and leave to watch her grandson in the pet contest.

What should you do? Actually, you have several options.

For starters, keep taking those big pictures. You can save those photos as your originals and use a computer program to save a smaller version for email or web posting. If you don't want to do it yourself, your friendly photo processing lab can save your original high resolution files on a CD/DVD and also make you a set of low resolution photos.

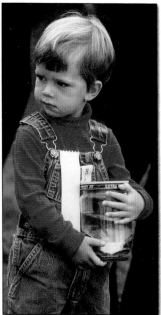

However, if emailing Aunt Harriet is all you're worried about, you can let your email program do it for you – most email programs have a setting to control how large an image can be, going out, regardless of what you dragged in or attached. (When the little box comes up and asks if you want to "make your picture smaller," say yes!)

I recommend saving your images at the highest resolution because we're photographers and we don't want to miss the shot of a lifetime.

©Marsha Hobert

Photography books always stress the importance of using a tripod, and if you can't use a tripod, use a monopod, and if you can't do that, forget it.

Only we can't forget it, because we want to make great animal photographs and unless we're doing a formal animal portrait with a handler and a prop person, we can't set up a tripod and get those spontaneous action shots like this one.

Which means we'll keep missing a lot of wonderful animal action shots because animals constantly move and we can't keep repositioning the tripod fast enough to capture action. Plus, a lot of our best shots are made from a low angle where our elbows will give us more stability than a tripod. (See p. 32).

©Marsha Hobert

So we can't use tripods.

To make you feel better, remember that tripod users might take all day to set up a landscape shot, while we make 10,299 digital images in the same amount of time! Sure, most of them won't make the cut, but we'll still have enough proofs to make the editor of *Kitten Wear Daily* flip for joy.

Practice these holding techniques until you have them down pat.

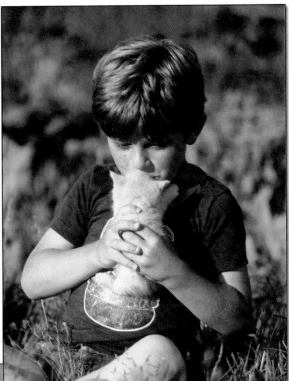

Camera up to eye

Hold your camera with both hands and brace it against your forehead as you look at your subject through the viewfinder. Brace your arms against your body for more stability.

If you wear glasses, you won't be able to press your camera against your forehead, so you'll need to take special care to brace your arms tightly against your body or a solid object like a fence.

Your feet should be slightly apart. When you are ready to take a photo, squeeze, don't jab the button, and hold your breath. If there is a fence or post nearby, use it to lean against for even more stability.

For small animals, bend or sit down and use your elbows to brace the camera on your knees.

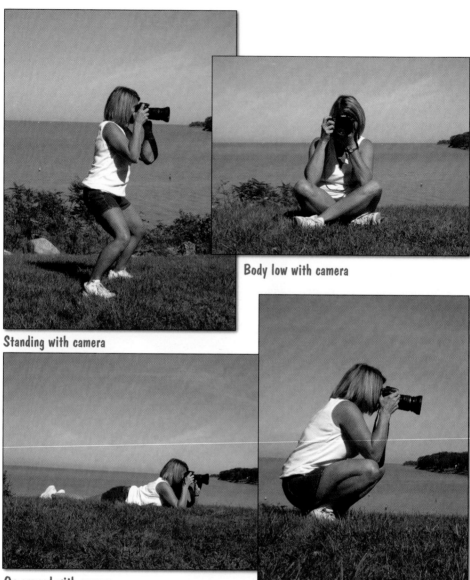

Body low with camera

Standing with camera

On ground with camera

Using your body as a tripod

Or stretch out on the ground and brace yourself on your elbows holding the camera firmly in your hands.

Being an astute animal photographer, you'll notice that nowhere in this exercise did we practice holding techniques looking at the LCD screen. Because it is usually difficult to *see* the LCD screen outside, plus we can't steady the camera in any of the ways shown if we are holding it out in front of us. The concept is to use our body as a tripod to steady our shots.

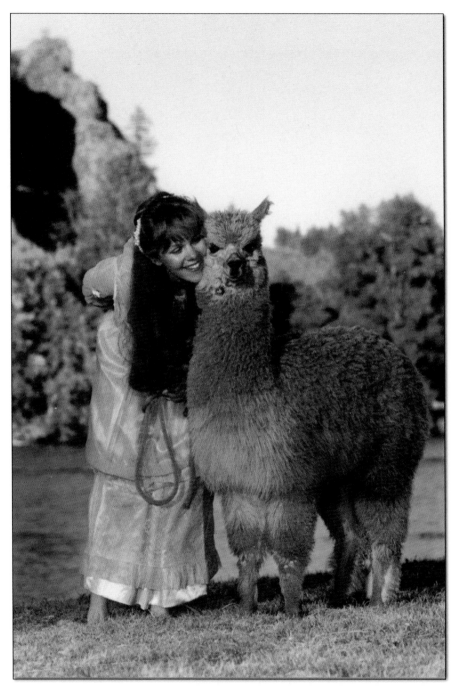

Cool, you've got it! Time to dress for that party!

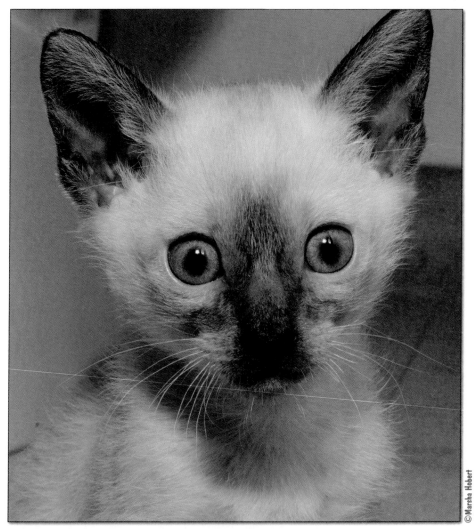

Yikes. That is a really big camera!

ogs are not our whole life, but they make our lives whole. – Roger Caras

WAS THAT A SABER-TOOTHED JACK RUSSELL TERRIER?

Being able to view your results on your LCD screen is a huge advantage with digital. But, learn how to utilize the information on the screen before you shoot—not while the action is happening.

Here's the drill. We have talked our dog breeder into letting our new puppy out of the crate for just a few minutes so we can create some images.

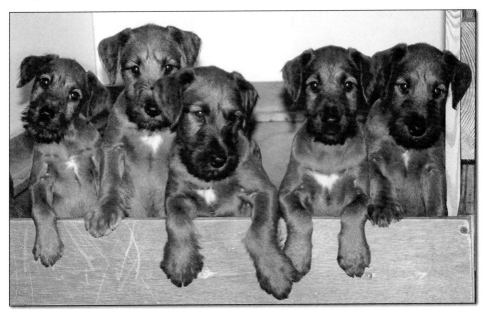

Once he's out, he is all over the place and we're so right there … click … click … click. Then we stop for a moment to check our images on the LCD screen.

But our puppy doesn't stop. Not for a second. He's into everything.

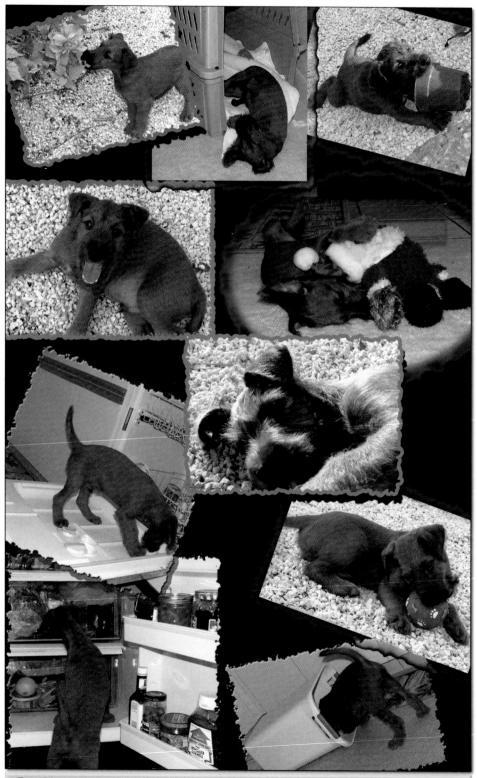

Then he sees two Jack Russell terriers with teeth like saber-toothed tigers fighting and wowzer … we know *Dog Dentist Magazine* will want photos so we begin shooting like crazy, but it's too late! We missed *the shot* because we were looking at the LCD screen.

Don't do that! Stay ready by setting everything up before you begin to shoot. (See Chapter 19, page 115.)

You can also use the LCD screen to check your focus; but be careful. Basically everything looks sharp and in focus when you view it on the tiny screen. If your camera has a zoom button for the LCD screen, zoom in to check the sharpness.

Of course, you can wait until you view your proofs or enlarge your images on your computer, but by then it's too late. So get in the habit of checking sharpness with the zoom button until you have mastered good focusing techniques.

When we zoom in on this image, we see that the dog, which looked sharp on the LCD screen, is really too soft to make a good enlargement. (See focusing in Chapter 9.)

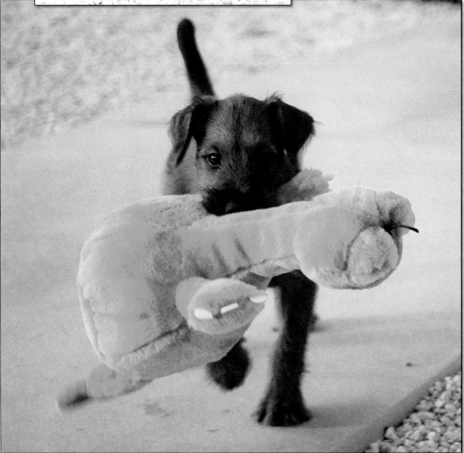

Sharp images are the goal of all great photographers.

\mathcal{P}hotography takes an instant out of time, altering life by holding it still. – Dorothea Lange

ALWAYS FOCUS ON THE EYES

Autofocus has kept many a professional photographer from taking up bungee jumping. In the old days, they had little choice when confronted with the prospect of calling up their client to tell them they didn't get half the wedding shots in focus. Yikes … time to jump!

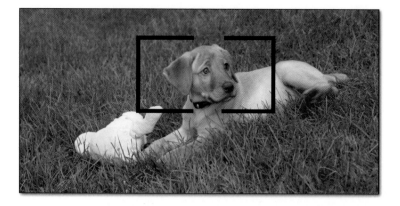

To use autofocus correctly, you simply aim the focusing frame (the small bracket or rectangle in the center of the viewfinder) at your main subject and press the shutter release button HALFWAY down. This will show the camera what you intend to focus on. Most cameras have a green light at the bottom of the viewfinder frame, or emit a beep (check your manual) to tell you the camera is focused. Wait for that signal before pressing the shutter all the way down to complete the exposure.

The focusing frame is usually in the center of the viewfinder (unless you have a newer camera with off-center, or variable focusing areas such as face recognition). Aim the focusing frame at your subject, press the button halfway down and hold it down while you move the camera to compose the scene. Then press the button all the way down to take the picture.

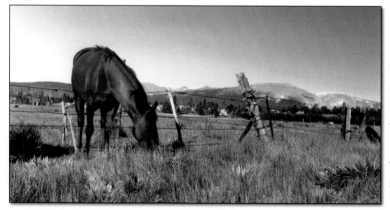

Point the focusing frame at the horse, lock in the focus, then recompose the image and shoot.

Sounds easy, right? Well, it is as long as you remember that the auto-focus rectangle is just that, automatic. There are any number of situations where the autofocus can become confused. For starters, it doesn't discriminate among things that are close together so it may focus on the wrong one. You must do the discriminating.

Here the photographer did not use careful technique and focused on the fence instead of the goat.

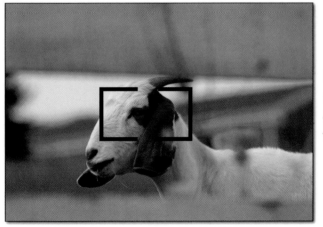

Place the rectangle on the goat, lock in the focus and shoot.

Every lens has a minimum focusing distance, so it won't focus if you are too close to your subject. To keep from being too close, you need to carry a small tape measure in your pocket that you can whip out to measure the distance from your subject. Attach one end of the tape to the subject, and walk backwards focusing on that subject until it is in sharp focus. Voila! Now you know the minimum focusing distance for that lens!

Or, if you want easy, just pull out your trusty manual and look up the minimum focusing distance for your lens. (SLR lenses have the minimum focusing distance printed on the lens barrel.)

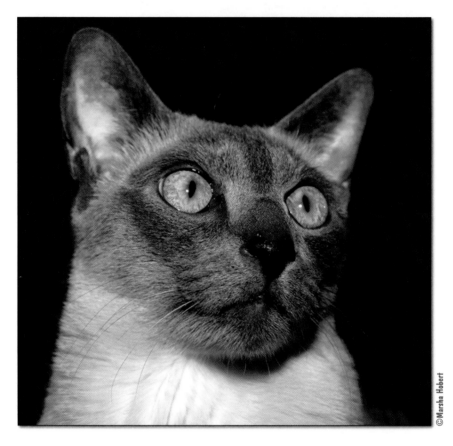

© Marsha Hobert

While today's top digital cameras have extremely fast autofocus systems for capturing animal action, remember that shooting anywhere between 10 to 15 frames in quick succession will cause the camera to pause while it writes to the memory card. So, check your manual to find out how many images can be stored in the buffer before the camera stops to write to the card. That way, you can pace yourself when you are working on an important action sequence.

If you are using an older point-and-shoot digital, you will have to deal with shutter lag (the delay when you press the shutter button), so get to know your system before those important action sequences and learn to pre-focus on the spot where the action will occur.

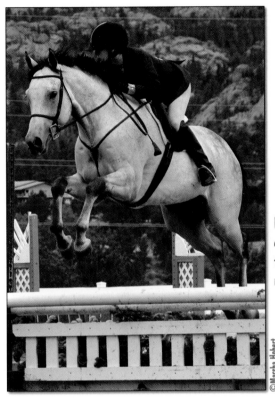

To pre-focus, find the spot where you think the action will happen, press the shutter button halfway down, hold it there, then fire when the animals move into that zone of focus. It helps if there is something that isn't moving for you to use as the focusing point, such as the bar in this photo.

Push the shutter button halfway down, pre-focus on the pole, then wait for the horse and rider to complete the exposure.

©Marsha Hobert

There are times when autofocus won't focus. Usually this happens when there is fog, a low-contrast scene or an image with a lot of space between the subjects.

There is a lot of "dead space" in this image where the autofocus can become confused.

You will know the camera lens is having trouble if it starts moving in and out trying to focus on *something*. When this happens, be prepared to switch to manual focus.

Since we can't use a tripod, one technique for getting sharp images during fast action is to switch to continuous shooting (burst) mode. To use the burst mode, set your camera on burst mode, hold down the shutter release and take a burst of photos instead of just a few. This will increase your odds of getting a few images that are sharp.

Count yourself among the lucky if you have this feature on your camera. You can still make dynamite photos without it, but if you plan to upgrade anytime soon, be sure to check out the list of must-have camera features for action on my web site at www.susanleyphotography.com.

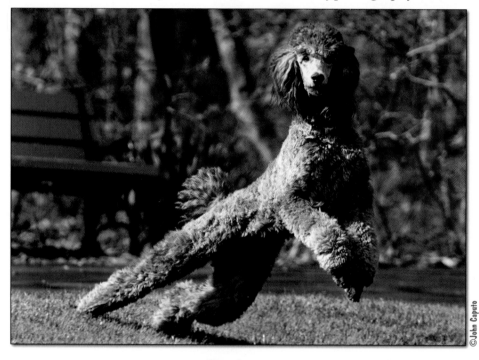
©John Caputo

Beginner

Practice focusing on the eyes of your subject until you can always take a photograph with the eyes in focus.

If NOTHING in the photo is in focus, it may be that the camera shook during the exposure. Go back to Chapter 7 and review the techniques for holding your camera steady.

Practice using autofocus on off-centered subjects until you have mastered the technique.

Advanced

Practice using autofocus on moving subjects until you are lightning quick when you are working with action. If there is a delay while your autofocus system locks onto the subject, master pre-focusing to capture action at its peak.

One technique that works well with pre-focusing, is to figure out where the action will be, pre-focus on that spot using autofocus, then switch to manual focus and leave the focus alone (it's set). When the action happens, you won't have to wait for the autofocus to get or miss the focus—you can just fire away on manual focus because you know the focus is good to go.

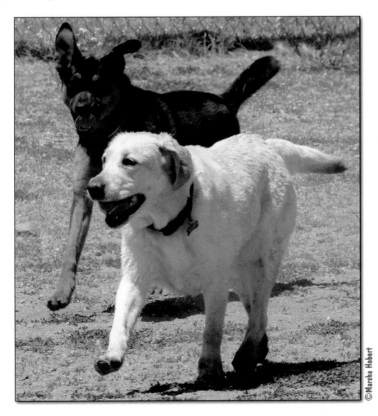

©Marsha Hobert

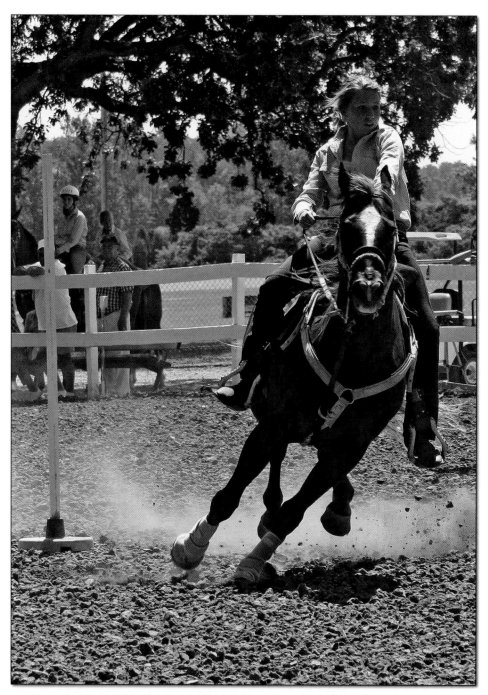

In a show arena with action everywhere, pick out a good spot for making photographs, pre-focus (in this case, on the pole) then wait until the action comes to you.

You don't take a photograph, you make it. – Ansel Adams

SIMPLICITY IS GENIUS.
SAY IT TEN TIMES.

Wow. Look at this scenery! Look at the mountain, the lake, the sky, the meadow, the tall evergreens … will this be a great animal portrait or what!

Well mostly what? As in, "what the heck were you composing this image for … an enlargement on the side of Grand Central Station?"

There is an *animal subject* in this photograph, but the photographer got carried away by the beauty and made a scenic image, so Aunt Harriet, who particularly wanted a photograph of her son and his llama, will have to book a train into Grand Central Station to view them on the side of the building. That's how large it will have to be to *see* them.

Guess she was mistaken when she hired us—she thought we were *animal* photographers.

Hey, right. We *are* animal photographers and we always move in close to give our viewers a sense of being right there.

This is one of the areas where the LCD screen is a terrific help because you can compose your images, then check to see exactly what you need to eliminate to get a dynamite photograph.

I like using the word dynamite when I'm thinking about how to make a good composition, because the best way to achieve a dynamite photo is to move in close and *eliminate everything else.*

This means you concentrate on one idea and one idea only. Keep checking that LCD screen to eliminate details that don't contribute to what you are making. In effect, you are cropping your image in the camera. Simplicity is genius. Say it ten times.

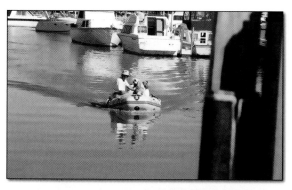

Move in close to give your viewer a sense of being right there.

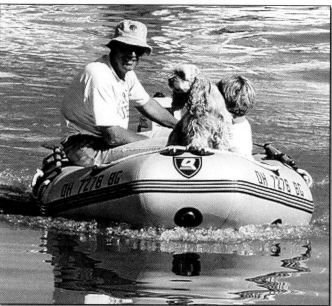

Before you begin to click away, take a moment to view your subject from different angles. Bend down, walk in a circle, do whatever you have to do to get a fresh viewpoint. This is one of the big secrets professionals use – they don't take the walk-up shot.

Always try to take both vertical and horizontal images when you are making pictures, so you have more creative options later.

With action shots, you may not have the option of careful planning. But if possible, leave some space in the photo for them to "move into." If their nose is right up against the edge of the photo when printed, it stops the action in the photograph and looks awkward.

When you are composing people/animal images, remember the importance of color. Warm colors attract the most interest and any bright color, especially red, pulls in the viewer and adds strength to the final composition.

©Marsha Hobert

If people in the image have color clashes going on with their clothing, eliminate them! Just kidding. But if you have the opportunity, get them to dress in colors that complement each other.

Placing all the elements of a photograph into a pleasing relationship can be difficult, especially when you have large size differences between animals and people. With small animals and adults, have the person bend or kneel down to relate to the animal, or have them pick it up.

With small children, this principle is reversed, but obviously there is no way to get large animals to shrink down to a child's size. Focus instead on having the animal and child relate to each other, so that the emotional bond will pull the viewer into the photograph.

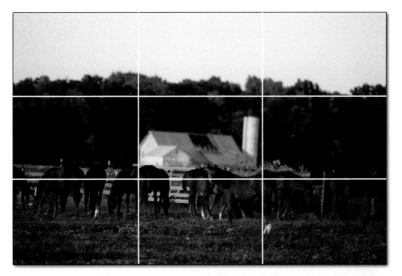

The Rule of Thirds: Dividing your image in the camera into nine parts and then placing your subject on one of the places where the lines intersect, is a tried and true compositional format for great images. However, with animal photography, I find that tight cropping utilizing the triangle principle below works best. This will place all the emphasis on your subjects and less on a compositional art format more suitable to scenics.

Try to set up your images utilizing the triangle principle – the most successful compositional format ever.

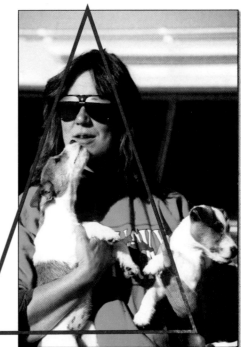

Less is more. You'll know you failed if you look at your photograph and have to ask yourself if you were making one picture or two.

Before we move on, I need to talk about grooming. You know … a shower, lots of hot water, clean teeth, clean hair, nice clothes … hey wait, I'm talkin' about grooming the animals. But it all goes together – you wouldn't have your photo taken without getting spruced up, would you? Well then, make sure your animal subject is perfect too.

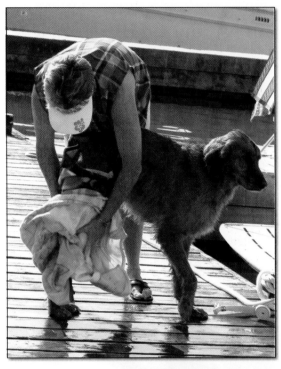

And don't forget the eye area – get out a washcloth and remove any matter from the corners of your subject's eyes.

Shows are a great opportunity to skip the tedious grooming routine; it's done.

Constantly analyze the pictures you see each day and look for the elements that make for a great photograph. Start a notebook and fill it with good visual images. Visit museums, read art books, and study the work of great photographers and painters to train your eye. You'll quickly find you are applying what you see to your own photographs.

Rules Are Made To Be Broken!

The composition is not well thought out. There are too many shadows and the background is poor, but the subject matter captures the eye and pulls the viewer into this idyllic scene.

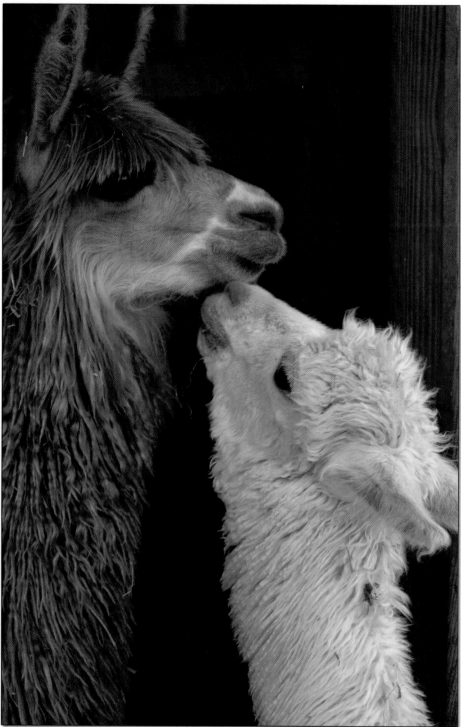

Always have your camera ready to take a sweet photo such as this.

When I take a picture, I take ten percent of what I see.

— *Annie Leibovitz*

ER ... WHAT THE HECK ARE WE CHECKIN' ON?

One of the mistakes beginners make is to take pictures without checking to make sure the background is clear.

Big mistake. Huge! Poor backgrounds ruin more images than any other factor except poor exposure. And it's so easy to control by running a pre-shoot check.

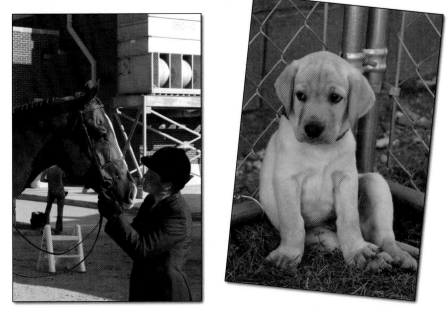

With action, you already know that there will be enough land mines to ruin your animal portrait without a lousy background, so get in the habit of a pre-shoot check.

Er ... so what the heck are we checkin' for?

Well, for starters, ask yourself, "is anything else in the viewfinder more noticeable than my subject?"

What about that stuff behind the horse's head? Or that chain link fence that makes the viewer think you made the image at Alcatraz? Or all the clutter – were you composing in a junkyard?

The necessity to make sure your background is perfect is just as important as packing your parachute before your next big jump.

Just kidding. Anyway, it is easy to control poor backgrounds. You already know that simplicity is genius. You already know you need to move in close. Those two things alone will eliminate a lot of your background problems.

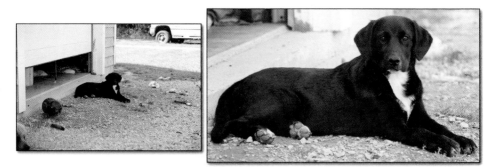

Even though there are still background problems in the close-up image of this black dog, moving in close and filling the viewfinder with the dog puts the emphasis on the subject and not on the clutter.

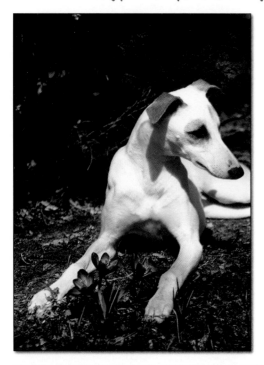

Here are more ideas for finding the perfect background.

Shoot light-colored subjects against something dark to make them stand out and to provide a more or less solid background. Green bushes or pine trees (with limbs that reach to the ground so you get that solid background look) are usually easy to find and they make an excellent background for light subjects.

Conversely, dark subjects look best against the sky.

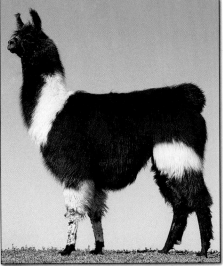

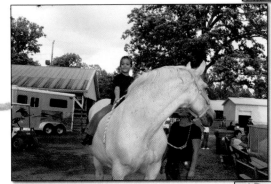

Finding a good background at an outdoor show can be a real challenge. There is so much going on in and around the show ring that your best option is to scout out the area nearby and try to find a better background.

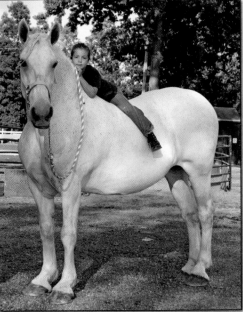

Even a very small hill can work if you lie on the ground and shoot up at your subject. Sure, the distortion from this angle might not produce a perfect image, but if it's a choice between eliminating a store and a parking lot, or shooting up to the top of the hill, choose the hill.

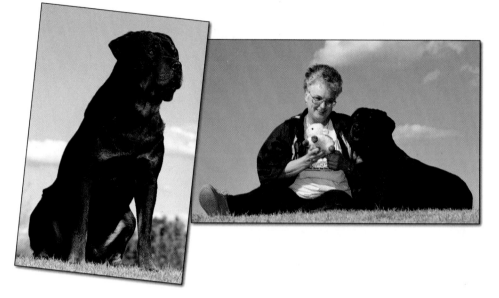

If none of the preceding options work, and you are shooting with an SLR (single-lens reflex) digital, it is time to pull out the big boy – your 200 or 300mm lens. A long focal length lens will compress the background and make it less obtrusive in the final print. Plus, long lenses magnify the subject so that the viewer has a sense of being right there.

For example, here's an image from my last trip to the Serengeti. No … wait … I said a 300mm lens was the way to go. I was shooting so tight at the zoo that the fence doesn't show. Brilliant, isn't it?

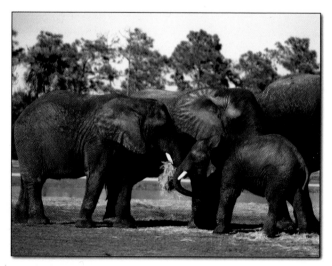

Go back to light (Chapter 5), and repeat the exercises with your main emphasis on the background. Write down the best locations in your notebook, including the lighting on those locations at different times of the day. Find the best spot to do serious portrait work.

If you have small indoor pets, do the same thing inside—look for the best indoor locations that have good light and a good background.

Try exposing your images on the portrait mode which is programmed to blur out the background even more. (See Chapter 12.)

Intermediate

You've exposed a lot of digital images duplicating the lighting conditions on page 22. Now go back and review your proofs, and shoot the same photographs with both good lighting *and* good backgrounds. Make notes so you'll remember the best locations with good light.

This will take more work than you might initially think. Suppose the light is perfect for making fantastic images of the horses frolicking in the south pasture early in the morning, but the ugly barn behind them makes the location unacceptable.

However, when you check out the same location in late afternoon (the slanting rays of the sun have now done a 180), you have a totally different background, and this one is clear.

Make notes on the best locations for good backgrounds combined with good light.

Practice using a long lens (200mm to 300mm), which will help to eliminate poor backgrounds, especially when you choose an aperture of f4 or f5.6. (See Chapter 15.)

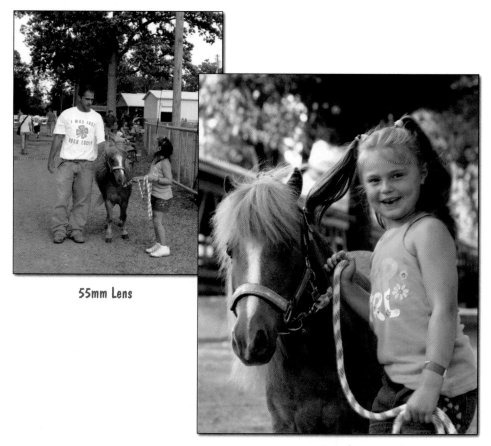

55mm Lens

200mm Lens

Remember that as you increase the focal length of the lens, you have to increase the shutter speed to compensate for camera shake. The rule of thumb is to increase your shutter speed to the focal length of your lens. If you are shooting with a 200mm lens, set the shutter on 1/250 of a second; if you are shooting a 300mm lens, shoot at 1/320 of a second.

If all of the above sounds complicated, that's because it is. This is why it is much easier to try and find a great background and not have to worry about all the other variables.

Rules Are Made To Be Broken!

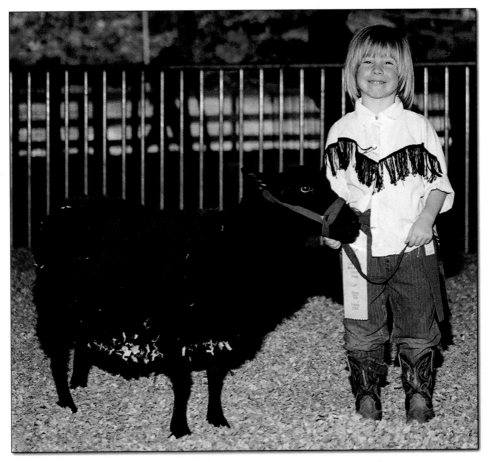

The background couldn't be worse, the halter isn't on correctly and
the animal obviously needs grooming. But, the expression on the
little girl's face transports this image into something wonderful.

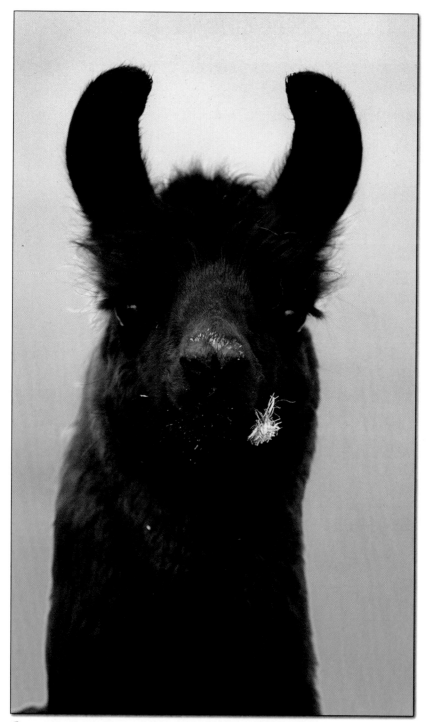

To capture your pet's personality, frame the image in your camera for a tight crop,
focus on the eyes, and shoot with a long lens to blur out the background.

\mathcal{E}very other artist begins with a blank canvas. The photographer begins with the finished product. – Edward Steichen

HOLDING ON FOR DEAR LIFE

©Marsha Hobert

We're not actually *holding on for dear life* when we set our exposure, but it is tricky. I have therefore broken it down into two chapters. This one is for beginners who want to *have fun* and the next is for serious photographers who are too busy being serious to remember that exposure is fun. (OK, that's an exaggeration – anyone who thinks exposure is fun really needs to get a life.)

But there is a message here. When you first start photographing, every picture you take is wonderful and you are creating in the moment enjoying every image you make. However, as you attempt more difficult shots, everything goes to heck and pretty soon, every day is a bad hair day.

©Marsha Hobert

Start with the **basic zone** settings, which are represented by icons on your command dial. Each time you make an icon choice, you are telling the computer in the camera what kind of photograph you are making so the computer can set the exposure.

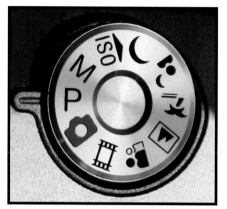

Here is a typical point-and-shoot command dial

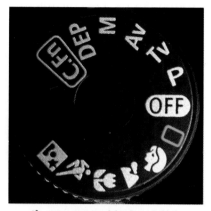

Here is a typical high end SLR (Single Lens Reflex) command dial

If you are not sure how to set exposure, put the dial on the GREEN ICON which represents the fully automatic mode.

© Tammy Shanahan

 If you are photographing animals in action, put the dial on the SPORTS icon.

 If you are taking a close-up, put the dial on the PORTRAIT icon.

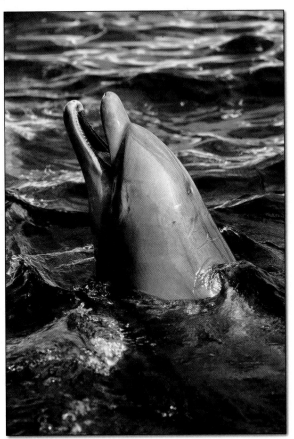

To understand how your camera computer comes up with the correct auto exposure, pretend for a moment that your camera is a bucketful of paint.

All the light you see pours through the lens into the bucket where the computer blends it all together. As the colors (or tonal values if you are shooting black and white) mix, the color that is produced is 18% (middle) gray. It's about the color of your favorite dolphin, but more importantly, it is the color camera meters are calibrated to produce with every exposure.

So why, since you are a charter member of the *"Let's Have Fun Club,"* do you have to know this stuff?

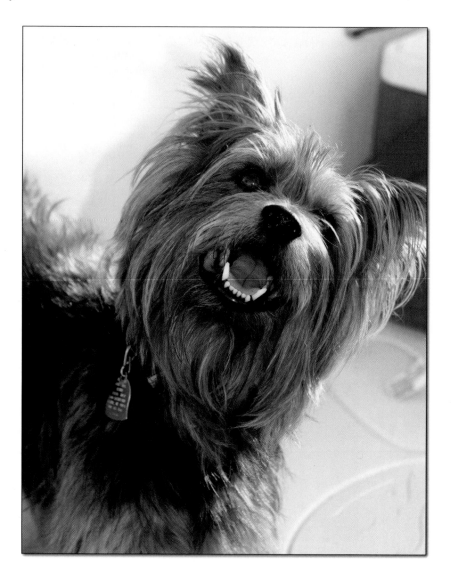

Because the meter wants to produce 18% middle gray with every exposure. It doesn't discriminate among the different objects in the scene. It doesn't give more importance to the tonal values of one object over another. This works well as long as there is a good balance of tones from light to dark, but with animal and people photography, we usually don't care about all the light in the scene; we care about the light falling on the subjects.

Here are some common problem areas that have easy solutions.

You shoot an animal portrait with a lot of bright sky included in the picture. The meter reads the bright sky and says, in effect, "I need to shut down (shut out some of this light) to produce an average 18% middle gray exposure. When the meter shuts down, the animal gets even less exposure.

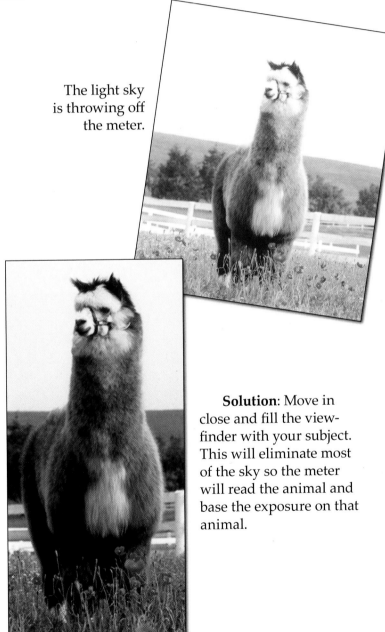

The light sky is throwing off the meter.

Solution: Move in close and fill the viewfinder with your subject. This will eliminate most of the sky so the meter will read the animal and base the exposure on that animal.

There is too much glare in this photograph because you are shooting into the sun.

Solution: Move around until you get rid of the glare. When possible, always try to position yourself to shoot with the sun behind you.

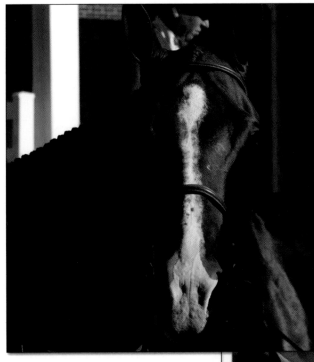

This
photo is
too dark.

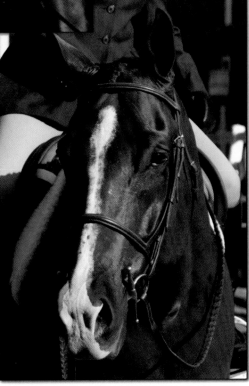

Solution: Move the animal into the light. Or, if there is not enough light to take the photo, change the ISO setting. (See Chapter 14.)

Once you have mastered these basics, you'll be ready to attack the creative side of your camera's command dial, where *you* must do the thinking instead of the camera.

This chapter is for you! Start by learning what each icon on your command dial is for, and what it does, by taking a series of photographs with your command dial set on each one.

Then, study the common faults described in this chapter and practice, practice, practice, until you can duplicate the "good" examples in this chapter.

Good job! Well done.

Is that a mouse??!!

Twelve significant photographs in any one year is a good crop.

– Ansel Adams

I TOTALLY GET THIS EXPOSURE THING!

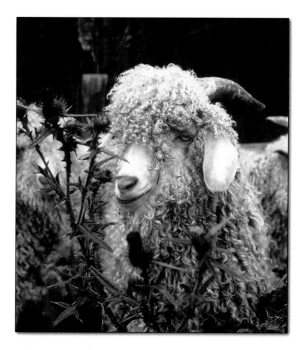

Well, sure you do because you're an intermediate or advanced photographer. If you're not, skip this chapter and come back later when you are ready.

Let's start with a quick review.

▲ Shutter Speed and Aperture

Exposure is determined by three factors working together: aperture, shutter speed and the ISO speed.

Let's master aperture and shutter speed first. Then you will be ready to tackle changing the ISO speed. (See page 86.)

The **aperture** is essentially a hole in your lens that lets light pass through to the image sensor. By adjusting the aperture, you determine **how much light** reaches the image sensor. You do this by selecting an aperture number on your camera (referred to as an f-stop.) The "f" stands for focal length.

The smaller numbers on the scale produce less depth in your images and the larger numbers produce greater depth.

The **shutter speed** determines **how long** the light is exposed to the image sensor. By adjusting this dial, you control movement. A fast shutter speed (1/250 sec or faster) will freeze movement, while a slow shutter speed (1/60 sec or slower) lets it blur.

It is important to note that your camera's digital readout represents shutter speed numbers as whole numbers when in fact they are fractions, so 250 is actually 1/250 of a second, and 60 is actually 1/60 of a second. If you don't understand this, you won't be able to figure out how these two variables work together to create exposure.

Shutter speed and aperture are inversely related. As the shutter speed is increased, the depth of field is decreased. And conversely, when the shutter speed is decreased, the depth of field is increased.

It is easier to understand and study the relationship with this chart, which shows some of the combinations you can choose:

Aperture (measured in f-stops)

f	2.8	4	5.6	8	11	16	22
Shutter Speed	1/1000	1/500	1/250	1/125	1/60	1/30	1/15

Each of these combinations will produce the same exposure, but not the same result in terms of the final image.

Once you study and memorize the chart (you'll thank me later if you do), you'll understand why a fast shutter speed is the way to go with animals. You need a fast shutter speed to stop the action, and the second-ary result of this choice is that the depth of field is reduced. The more you reduce the depth of field, the more the background is blurred. The more the background is blurred, the more the emphasis is on the subject.

▲ Shutter Speed or Aperture Priority

While many of the current point-and-shoot cameras have sophisti-cated features, if you're an advanced photographer, I'm guessing that you have given away your point-and-shoot camera, and graduated to a digital SLR with interchangeable lenses. These cameras will have all the bells and whistles to give you total creative freedom.

One terrific feature is the ability to set your mode dial to shutter speed or aperture priority. If you want to stop the action, you set your dial on shutter priority with a speed of at least 1/250 of a second or higher, and you're good to go. Conversely, if you want a lot of depth in the photo, you set your dial to aperture priority with an aperture of at least f/8, and you're good to go.

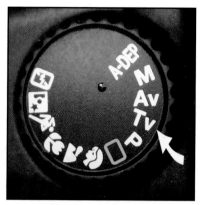
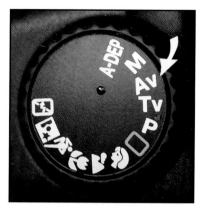

Shutter speed priority Aperture priority

So, how do you set your camera on shutter or aperture priority?

Check your manual. That is where you will find all the details, so study those sections and your images will be even better.

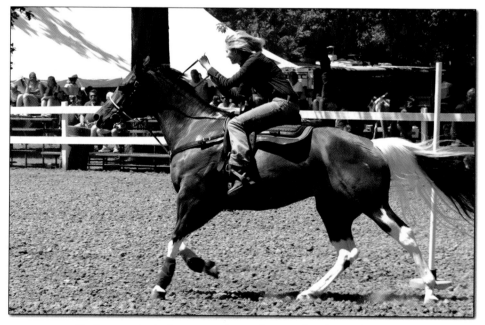

Shutter speed priority set on 1/500 of a second to freeze the action.

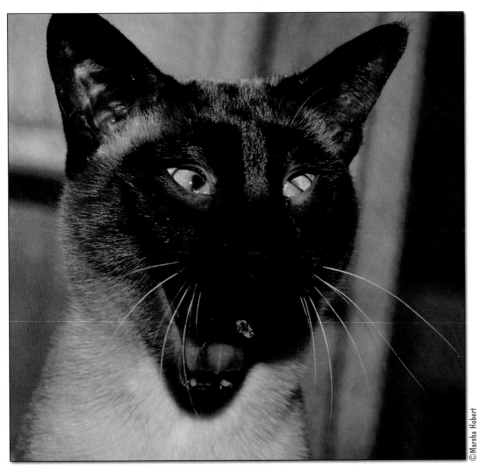

©Marsha Hobert

Manual, yikes!

Intermediate

1. Shoot a series of photos on shutter speed or aperture priority. Study your results and decide if you chose the right settings for the images you were making.

2. Refer to the white balance chart in your manual and make photographs at each setting. Then try making one photo with auto white balance and the same photo with the corrected white balance. Study the results so you'll know when you need to change the automatic setting, and when it's OK to just leave it on automatic. (High end digitals are pretty good at coming up with the correct settings on automatic.)

White Balance:

If you are shooting in RAW (see Appendix A) format, it is not necessary to worry about white balance because you can adjust it later in Photoshop. But obviously it is a good idea to choose your white balance in-camera. Then it takes less of your time to adjust color later in your image enhancement computer program.

Manual Exposure:

When you choose shutter or aperture priority, the camera's computer will default to the maximum speed or the maximum aperture based on the light.

Here's how it works. Say you want to freeze the action, so you set a shutter speed priority of 1/250 of a second. The camera will now set the other variable—aperture—to the highest number it can choose (depending on the light) to balance the exposure.

But, what if you want less depth than the camera will set? This is where manual exposure comes in. If the light will allow you to increase the shutter speed to say 1/500 of a second, then you'll have less depth in the image. (Remember, it's an inverse relationship.)

Conversely, if you want a lot of depth, you set aperture priority and the camera will choose the highest speed it can choose (depending on the light) to balance the exposure. But while the shutter speed may produce a correct exposure, it may be too slow for the action in the photograph.

Try turning off all your automatic settings and going manual. Before long, you will be doing the thinking instead of your camera.

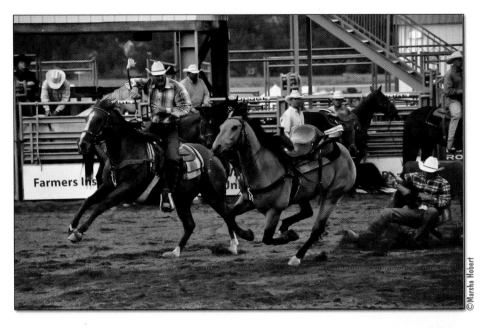

Which was taken with shutter priority, and which with aperture priority?

This is an easy question, so if you don't know the answer, read this chapter again! (Answer on page 89.)

Chapter 13 – "Advanced Exposure"

Each moment has its own beauty…a picture which was never seen before and which shall never be seen again.

– Ralph Waldo Emerson

THE NEED FOR SPEED

We're animal photographers. Unless we are deliberately making a photo using blur, our aim is to freeze the movement so the image is sharp. This means our speed is set to at least 1/250 of a second to freeze the action. If the movement is very fast (puppies romping, horses galloping), use 1/500 to 1/750 of a second.

It is easier to see in a series of photographs.

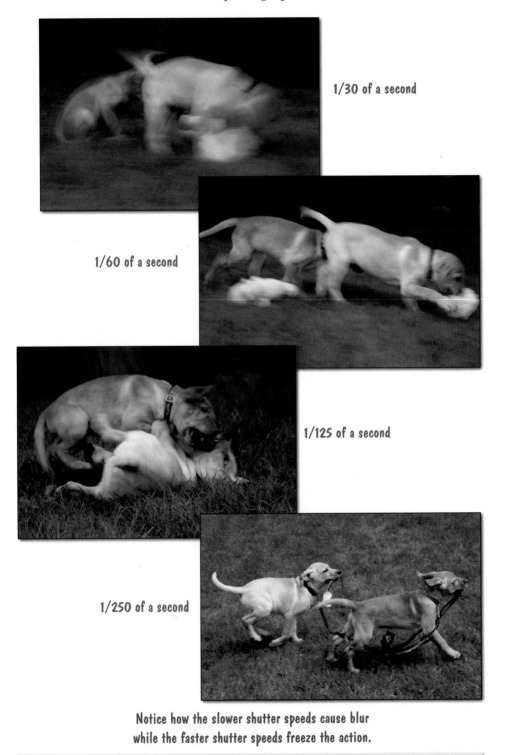

1/30 of a second

1/60 of a second

1/125 of a second

1/250 of a second

Notice how the slower shutter speeds cause blur
while the faster shutter speeds freeze the action.

▲ Using a Long Lens With Action

If you are using a long lens, you will have to set the speed faster to compensate for camera shake. The rule of thumb is to increase your shutter speed to the focal length of your lens, so if you are shooting with a 300mm lens, set the shutter speed to at least 1/320 of a second.

Using a long focal length lens with action (200mm - 300mm) will blur out the background more than shorter focal length lenses (55mm - 100mm) even with the same f-stop, because the distances will seem to be compressed more with the longer focal lengths.

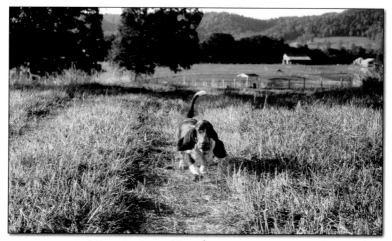

55mm lens

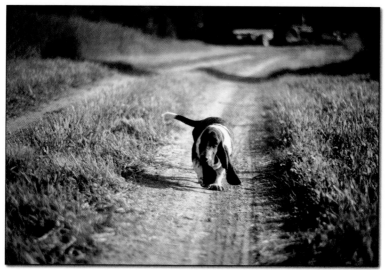

200mm lens

▲ Changing the ISO Speed, the Third Factor for Correct Exposure

For those times when you have set the f-stop to f2.8 or f4, and you don't have a fast enough shutter speed for action, change the image sensor's sensitivity to light to a higher setting.

Digital has retained the principles, terminology and rating systems used for film cameras, so the terms are the same. Going into the menu and changing the image sensor's sensitivity to light is the equivalent of switching to a higher or lower ISO speed film.

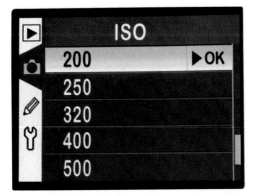

As with film, for the best clarity, you want the lowest ISO setting you can use depending on the speed of the action and the light. Keep this setting at 100 or 200 and you'll have a lot less noise in the final image.

I'm not talkin' about the noise your pelican makes when he opens his mouth to swallow a large fish.

I'm talkin' about the speckled effect you get with digital at high ISO settings – it is the equivalent of grain with a film camera. But the great thing with digital is that you don't have to burn a roll of film before switching to a higher or lower ISO speed. Just change the sensitivity setting whenever you need more speed and lower it again when you don't.

When in doubt about your exposure, it is better to *slightly* overexpose rather than underexpose because there will be less noise in the final image. That is because noise is most prevalent in the shadow areas so when an underexposed image is lightened, it also lessens the noise.

▲ Master Pre-Focusing

Once you master pre-focusing (see page 43), your odds of capturing great action will far surpass the professional who doesn't know your subject. See, they don't know the route Morgan is going to take to catch the ball, but you do, which means you are prepared to catch the action at its peak.

Pre-focusing will increase your chance of getting "the shot" with all digital cameras, but especially with the point-and-shoots where shutter lag (the delay when you press the shutter button) will interfere with your ability to capture action.

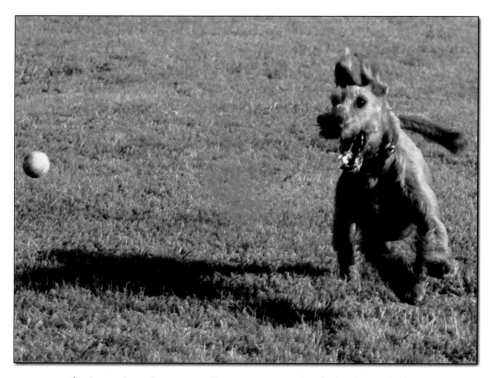

You know where the action will occur, so press the shutter button halfway down, hold it there, then fire when the animal moves into the zone of focus.

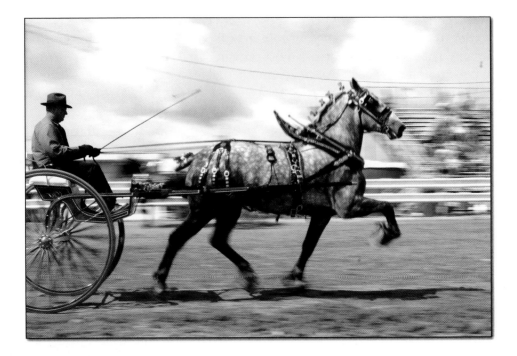

▲ Try Panning

With panning, you emphasize the motion of the animal by deliberately letting parts of the image blur. If you want to master this technique, be prepared to put in some difficult practice time.

Start by setting your speed at 1/15 to 1/30 of a second (you can set the camera to shutter priority if you have that feature).

Get in a good stance. Focus on the spot in front of you where the action will happen and hold the shutter button halfway down. (Now you are pre-focused and ready.) As the animal approaches, follow it with your camera as if you were shooting a gun at a moving target, pushing the shutter release when the animal is directly in front of you. Continue to follow through, moving the camera with the animal as it runs on by.

The idea is that you are moving your camera at about the same speed as the animal, so the animal remains sharp while the background blurs.

If you have a continuous shooting (burst) mode, use that feature to increase your chances of getting "the shot."

With panning, poor backgrounds become a rush of color, so this is a great technique to use when you have a poor background.

Pre-focusing is also essential to capture split-second reactions.

Intermediate & Advanced

Keeping your distance from the subject constant, take a series of action shots, varying only the shutter speed. Don't worry about balancing the exposure – just study the effect of the chosen shutter speed on the action in each image.

Try the same thing with different focal length lenses, and/or different focal length settings with your zoom lens. It's much easier with shorter lenses (55mm - 135mm), but keep working until you master speed with a long lens (200mm - 300mm).

Answer to the question on page 82. Top photo - shutter priority. Bottom photo aperture priority.

less depth), and stopping down the lens (choosing more depth), as we move up and down the scale.

Typical f-Stop Scale:

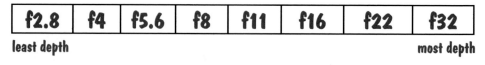

f2.8	f4	f5.6	f8	f11	f16	f22	f32

least depth most depth

In the photographs below, notice the amount of depth in each image.

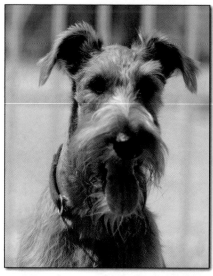
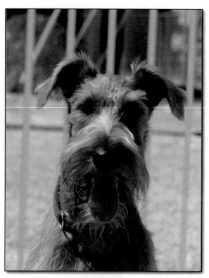

f/4 f/11

See how much less depth there is in the photograph labeled f/4 than the one labeled f/11? That's the whole concept behind depth of field.

▲ Choose Less Depth to Isolate Your Subject

Since we know there is an inverse relationship between aperture and shutter speed, if you choose an aperture of f/2.8 or f/4, you'll get more speed. Plus less of the background will be in focus. To throw even more of the background out of focus, shoot with a long lens.

▲ Mastering The 1/3 In Front; 2/3 Behind Rule

When we focus on a subject, the depth will always be 1/3 in front of the subject, and 2/3 behind the subject. Landscape photographers just set up a tripod, stop down the lens and focus 1/3 into their photograph. This method guarantees terrific depth of field in their images.

Let's watch their stress level rise like a cowboy with a scorpion in his sleeping bag. Let's make them take an animal portrait!

They will have to focus on the animal's eyes and use a shallow depth of field to blur out the background. They'll have to do that and try to get the long nose of the animal in focus too. Way tough, which means they've given up after a few tries and slunk off to look for rattlers in the rocks … anything besides photographing animals.

It's OK. We can make this image. We are animal photographers and we know what to do!

First, we focus on the eyes. If we have a depth of field preview button (which stops down the lens to the current aperture), we use that to check what is in focus.

Then we refocus just in front of the eyes, so both the eyes and the nose will be in focus.

Using our depth-of-field preview button, we see that the nose is in focus, but the eyes are out of focus.

©Marsha Hobert

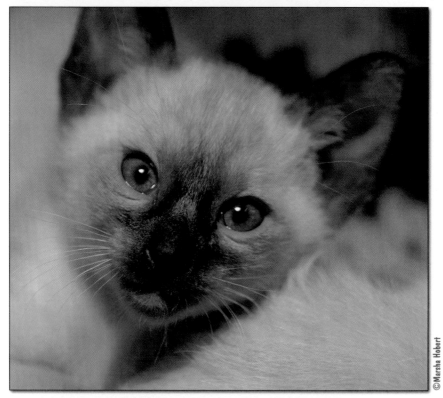

©Marsha Hobert

So now we refocus 1/3 into the face (pick a point just in front of the eyes), so that the nose and eyes will both be in focus.

Keeping your distance from your subject constant, take a series of photos varying the f-stop. As with the shutter speed series, we are not concerned with balancing the exposure. Just study the difference in the depth of field in each photo.

Distance from the subject and your lens choice will also affect depth of field. Check it out with your own tests and make some notes about which lens (or which setting on your zoom lens), gives you the best results.

Each lens has a sweet spot (its sharpest aperture), and you need to know what it is for each lens you use.

The light, the ISO speed, the focal length of the lens, how close you are to the subjects ... all these factors affect the depth of field, so take each factor, run tests and study your results.

Rules Are Made To Be Broken!

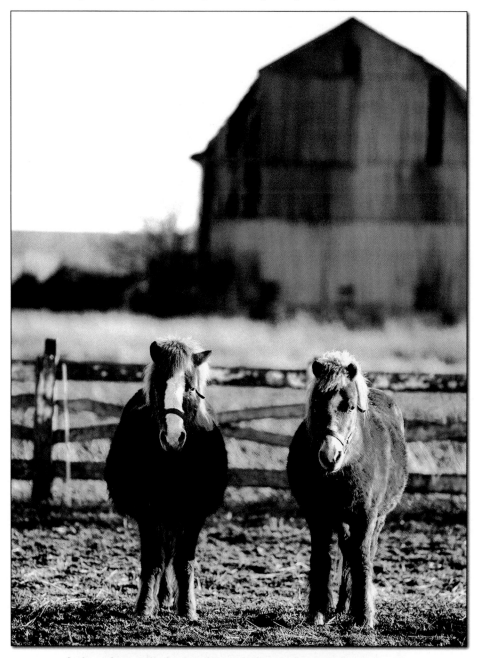

At first glance, the photographer might have been tempted to isolate the ponies from the background by choosing an aperture of f2.8 or f4. But by choosing a mid-range aperture, the rustic barn and fencing become a backdrop that adds interest and conveys a unique sense of place to the viewer.

There are always two people in every picture: the photographer and the viewer. – Ansel Adams

PLUS, I'M STILL ALIVE!

Whenever you build up a stack of photos, you need to do a careful critique. Your images should function as report cards, so be open and ready to learn.

Start by throwing out any photos with poor exposure, poor backgrounds, incorrect focus – any major fault that makes them unacceptable for further viewing.

Then look for problem areas (for instance, fuzzy action shots) indicating that you need more work in that area. Set those aside, marked for practice.

Next, look at each remaining image as if *someone else made it*. This will force you to see faults that you might otherwise overlook.

See, here's what happens. You view your images of the charging buffalo crashing through the brush and you think, wow! These are fantastic! These are terrific! I kept my cool and got the shot! Plus, I'm still alive!

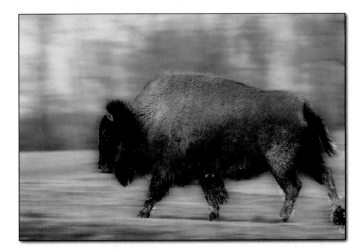

In reality, the images are a bit blurry, so they belong in the trash, but you're already planning an extravaganza. You're thinking, *what about dinner for 200 of my closest friends? I'll have a scintillating slide show of my escape from death, featuring my nimbleness with camera controls under the pounding hooves. Well, not exactly under the hooves, but darn close!*

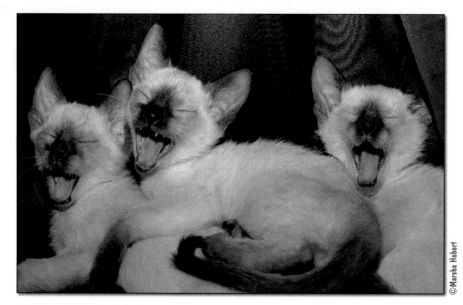

©Marsha Hobert

But during the show your guests are yawning.

A few more minutes and they'll be sound asleep. And who's fault is that? The photographers who work for *National Geographic*, that's who! Their images are so fantastic they have completely ruined your chance to be famous at your own party. You might as well go back to teaching your terrier to drive the boat.

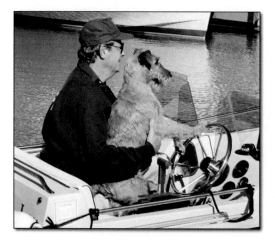

What went wrong?

When you viewed your images, you were reliving the moment you took the photographs and *adding in extra information*. Remembering the danger and the challenge, you thought you did a terrific job to capture anything at all.

Sure, you did a good job, but that doesn't mean you took a memorable photo.

Your audience is viewing what is *there*, not what you *felt*. So, keep working to combine both *seeing and feeling* into your images, and your photography will continue to improve.

The key is to examine every detail and be careful not to *add in information* when you do your critique.

Let's examine some images to assess the emotional tone they convey.

How about this one?

This is the place where I get on my soapbox and talk about ears. Alpaca ears, horse ears, dog ears, cat ears, Aunt Harriet's ears. Well, not Aunt Harriet, but then you wouldn't photograph Aunt Harriet with a frown on her face, and you shouldn't do that to your animals either.

Because, ears back signify anger or unhappiness or fear and those aren't the reasons we are into photographing animals. Animals live in the moment. They smile. They have fun. They play. That's what we want to capture.

If you are not into photographing the joy your pet feels, perhaps what you really want to do is work for *Veterinarian News* and photograph animals sitting in the doctor's waiting room?

Go for the good things pets bring to our lives and work to be sure you don't catch them with their ears back.

Sometimes you get fooled. It happens when you do that "reading into the photograph stuff that isn't there" thing.

Here is a good example.

I know there is a loving relationship between this small child and her dog, because I observed it when I took the photograph. When I view this proof, I read in that loving relationship. But the viewer sees a dog with the ears pasted back, and a small child who seems to be pushing an unwanted kiss upon its nose. They see what is there, not what I saw when I made the image.

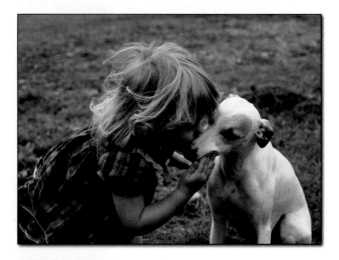

Here's a similar subject, but look at the difference in the emotional tone. The child is enjoying her pet – the pet is relaxed with his ears up—this is a happy pair and we don't need any words to enjoy this moment. Everything is positive and the viewer is pulled in to enjoy it as well.

What about this image? The moment has been captured so well that we clearly see how these two feel about each other.

Here's another image we really want to explore. The boots are adorable, the hold

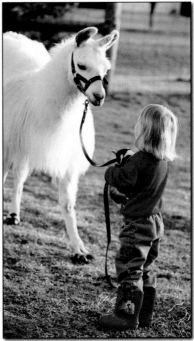

on the lead rope is light and relaxed, and the llama is part of the relationship. It says llamas are curious… they like small children… small children don't need to be afraid of them … it's fun to stomp around the field in your boots … life in the country is good. This image would make a terrific ad.

Always remember that *pictures convey messages without words.* Not only do you have to work at the craft of photography, but you have to edit consistently, always working toward that connection between seeing and feeling that all great photographs have.

A great photograph will always affect you on an emotional level. To produce great images you must ruthlessly edit your work.

Beginner & Intermediate

We're part of the *"Let's Have Fun Club,"* and we aren't going to load our images onto our computer because we don't have to or want to. We simply take our memory card to a service lab and have them make prints. When we get those prints back, we chop and crop as suggested in Chapter 17.

Advanced

We've viewed our images, made a backup, and now we are going to do a ruthless edit and throw away any images that are out-of-focus, have exposure problems that can't be corrected or are just plain boring (no emotional impact).

After that, the sky's the limit. Colors can be changed, people and objects can be taken out or added in, backgrounds can be eliminated, legs can be moved into the proper stance, ears can be cloned (take the best ear and make a copy for the other side), wool gaps can be filled, Aunt Harriet can have a whole new look.

If you're an artist, this is your new playground.

But before you begin to play, remember to backup your files on the mass storage device of your choice. Make two copies and put one away in a safe place. There is nothing more heartbreaking than losing your work because you didn't properly back it up BEFORE you made changes.

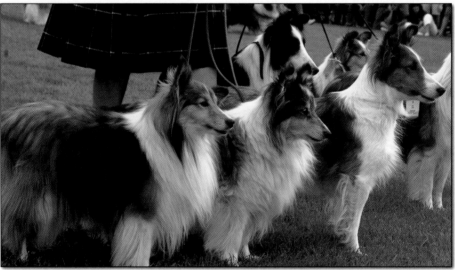

We are drawn into this pleasing composition of dogs all looking in the same direction, ears up and bodies alert. This image took extreme patience on the part of the photographer who waited, camera ready, for the perfect shot.

Hopefully by now, the members of the "Let's Have Fun Club" are trying the suggestions in this chapter on how to edit their photos.

But, if you enjoy working with your photos on a computer, here is an example of what you can do.

The artist who took this image (who is incidentally, the artist who designed this book), wanted to change the background of the photo, so she traced around the elk using a selection tool in Photoshop, eliminated the background and added another picture that she took for the background. Cool, huh?

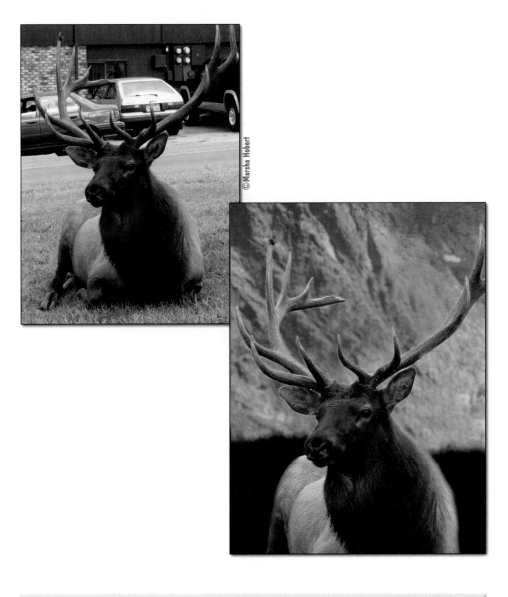

©Marsha Hobert

Rules Are Made To Be Broken!

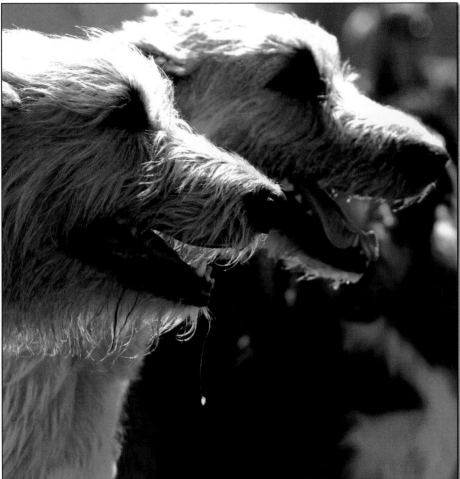

Even though the ears are back, the motion and the rapt smiling faces
convey the sense of fun and excitement of these two Irish wolfhounds.

There is just as much horse sense as ever, but the horses have most of it. – Author Unknown

CHOP & CROP ...
LET'S GET IT DONE!

Before you start doing a lot of fancy manipulations to your files, don't forget that one of the easiest ways to edit is to simply crop out the bad stuff, as in this image I took in the Rocky Mountains.

Actually, this one might have been made at my local zoo – where you, too, can make good animal images. You will be amazed at what great images you can capture by cropping with your camera.

Tight cropping works at home too.

Cropping your images in Photoshop obviously works, but the best way to crop is to plan ahead and do the cropping while you are making the image. Practicing this technique will remind you to always move in close and give your viewer a sense of being right there.

But more importantly, unless you are using a digital camera capable of saving huge files (16MP and up), drastic cropping may degrade the image when it is enlarged. (See Appendix A.)

So, for superior files, crop your image in the camera before exposure. Just keep clicking away and viewing your results on the LCD screen until you have a perfect crop.

©Marsha Hobert

©Marsha Hobert

Attending art shows, museums and constantly studying the work of the great masters will hone your eye. Keep throwing away the photographs that don't work, and eventually you'll have a solid body of great images that showcase your own unique style.

Rules Are Made To Be Broken!

We can't see the subjects well, but the beauty of the natural scene helps
convey the beauty of the relationship between this man and his dog.

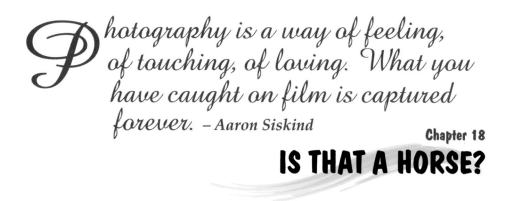

hotography is a way of feeling, of touching, of loving. What you have caught on film is captured forever. – Aaron Siskind

IS THAT A HORSE?

Your on-camera flash has a certain amount of power to add light to your images and you know what that amount is because you've checked your manual.

It is important to know, because the most common cause of failure when taking flash pictures is shooting so far back, that the flash doesn't have enough power to illuminate the subject.

Once you know what the correct flash-to-subject distance range is for the ISO setting you are using, your images will be correctly exposed as long as you stay within that range.

Every camera model has a different power range for the on-camera flash, so it bears repeating that you have to know the power range of *your* flash.

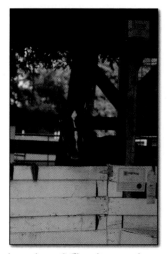

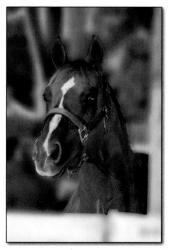

Is that a horse? The photographer was beyond the distance range of the flash, so the horse is underexposed.

Here, the photographer moved closer, so that the on-camera flash was able to correctly illuminate the subject.

When you are making images with more than one subject, be sure to keep them close together and the same distance from the image sensor so they all receive the same amount of flash exposure.

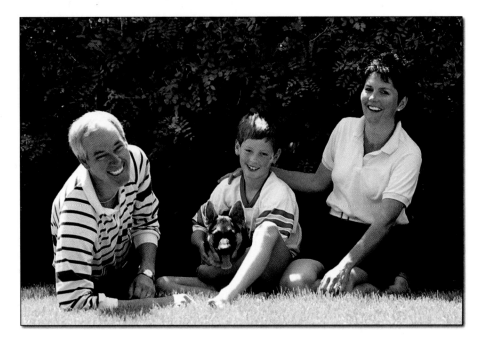

Good camera techniques were utilized in this photograph. The subjects are posed against a row of shrubs providing both a solid background and shade from the harsh overhead sun. Flash was utilized to even out the light. Notice how all the subjects are the same distance from the camera, so they all received the same amount of flash exposure.

If you are shooting a lot of flash photos in quick succession, you'll notice that it takes a few seconds after each exposure for the flash to recharge. During this time, it will either refuse to fire or fire at less than full power. Consult your manual, then practice so you will know how your flash will react *before* taking important photographs.

▲ Using The Built-In Flash On A Point-And-Shoot Camera

The small built-in flash on most point-and-shoot cameras is not powerful enough to add a lot of light to your photos, so be sure to check your manual for the flash range at each ISO and be very careful to stay within the range.

Because point-and-shoot cameras are small, it's easy to block the flash with your finger. Practice good holding techniques until blocking your flash with your finger will be oh-so-last-year.

▲ Using The Built-In Flash On An Advanced SLR Camera

On the automatic side of the command dial, the flash will pop-up and fire automatically when necessary.

On the creative side of the command dial, you set the flash power depending on what you want to capture in your photograph. Here are the basic techniques you need to master.

▲ Fill Flash

Using fill-in flash outside is one of the big secrets pros use to even out the light when the sun is casting shadows on their subjects. Start with front lighting.

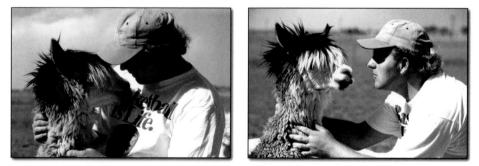

The photo on the left was made without flash. In the photo on the right, flash was used to even out the strong shadows. Just pop-up your flash, make sure you are within the range for the ISO setting, and shoot.

For fill-in flash with the sun behind the subject, pop-up your flash, meter the subject (page 119) being careful not to get the sun in the meter (we want the flash set to illuminate the subject), lock in the focus, check the distance range for the ISO setting, and shoot!

Using flash to fill in the shadows in shade will improve your images. In shade, your eyes even out the light, so you don't see the patchy areas until you view your images. (Set your exposure, pop-up the flash — it will add the correct amount of light.)

▲ Using The Red Eye Reduction Feature

Red eye is the annoying "devilish" red color in the eyes of subjects in flash pictures. It occurs when the flash hits the pupil of the eye in low light conditions.

If your camera has a red eye reduction feature (check your manual), be sure to turn it on when you are photographing in low light. When it's not necessary, leave it off – it works by sending out a short burst (to close the pupil) before the main burst fires, and that causes shutter delay. Plus it uses more battery power.

If your red eye reduction feature doesn't eliminate red eye completely, you can always use Photoshop or ask your lab to fix it.

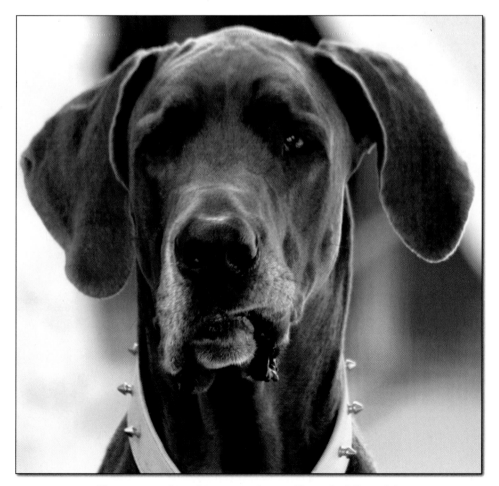

If you were making this image, what would you do differently?
Hint on page 94 and answer on page 126.

▲ More Flash Options For Advanced Photographers

If you find yourself in situations where you need more flash power, or you're tired of dealing with red eye, you might want to invest in an external flash.

Mounted to the side or top of your camera, it will recycle faster than your on-camera flash, eliminate red eye problems (the further the flash is from the camera lens, the less chance it will occur) and give you more shooting options in low light.

An external flash works just like your on-camera flash (when you press the shutter button, the camera evaluates the amount of light hitting the subject and cuts off the flash when the right exposure has been reached) but it has a lot more power. This means the distance range of the flash at each ISO setting is a lot more.

It is impossible to take good photographs inside a dark show arena unless you are very close to your subject or using an external flash. But even using a powerful external flash, you'll find that dark arenas "eat" the light. My rule of thumb is to set my external flash for one stop more exposure than indicated by the distance from the subject. (Set your shutter speed to the highest flash sync rate for your camera, then set the flash to +1.)

Inside dark arenas, use your LCD screen to check your
flash power at +1 and +2 *before* you begin to shoot.

No animal should ever jump up on the dining room furniture unless absolutely certain that he can hold his own in the conversation. — Fran Lebowitz

I CAN DO THAT!

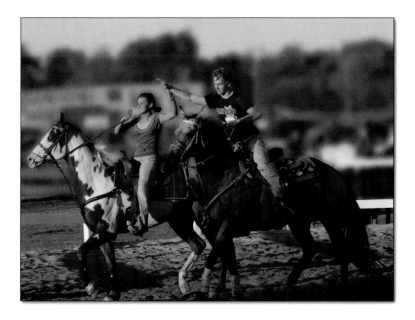

If you've been paying attention and putting in enough practice time, you're ready to do a "formal" photo shoot.

That takes work and concentration but you are ready!

Perhaps you need photos for advertising. Or you need a great image to post on your web site, put in a brochure or use in a show catalog. Or perhaps you want a great image to frame and give to a special friend.

The list is endless, but the point is that all of these uses require great photographs and making one involves a careful process that can't be rushed.

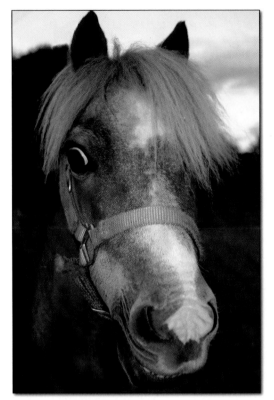

Let's get started.

My most important rule for a photo shoot with animals is to remember Murphy's Law. If anything can go wrong, it will! Being prepared is the key. You need to follow a careful step-by-step approach.

Start by deciding *when* you want to take the photo. (Chapter 5 – Lighting.)

Then decide *where*. (Chapter 11 - Backgrounds.)

Next, focus on the concept for your photograph. What do you want to say?

Decide on the concept, write it down and rough out the photo on paper. Or, if you aren't into drawing, collect photographs you would like to imitate and put them in a notebook to use as references.

Next, get the animal ready. Good grooming is essential! You wouldn't have your photo taken without getting cleaned up.

Depending on the animal, it is usually advantageous to do the grooming well ahead of the shoot. Otherwise, there's a good chance you'll both be worn out before you start. (That's why my suggestion to make important images during a show makes sense – the grooming is done.)

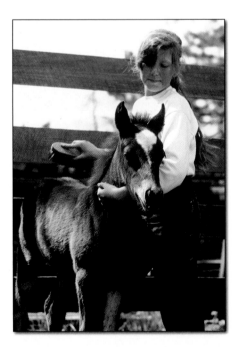

▲ Making The Candid Image Outside

You might want to start by just "hanging out" with your animal. Have the exposure controls set, and watch for your concept to materialize. You have your props ready, so when you see something worth capturing, *and not before*, throw a prop in the air to get the animal's attention, and shoot.

©John Caputo

This is much harder than it sounds. Patience is the key. Move slowly and wait for the shot. In the old days of film cameras, I would have added "...and don't burn film." But now, with digital, we can burn all the "film" we want.

But it's a bad idea. The photographer who is busy exposing frame after frame on the memory card isn't waiting for their paper vision to materialize.

Think about it. When you press the shutter button, your mind is basically focused on *the shot you just took*, so for a split second you are not men-

tally focused *forward* into the next photograph. If you are taking image after image without thinking through the process (notice I used the word *taking* and not *making*), you will end up with a lot of unusable stuff.

Professionals don't shoot when they know there is nothing in front of the lens worth capturing. They wait it out, saving their mental focus for the photo op that happens when they watch and pay attention. *Then* they burn that card!

If your patience disappears, stop and come back later.

▲ Making The Formal Image Outside

An alternative to a candid image, is to do a formal image with a lead attached to the halter. The lead will be removed later with your computer software or by your lab. (Using fishing line for the lead is a great option if you are working with a quiet animal because it's so easy to remove.)

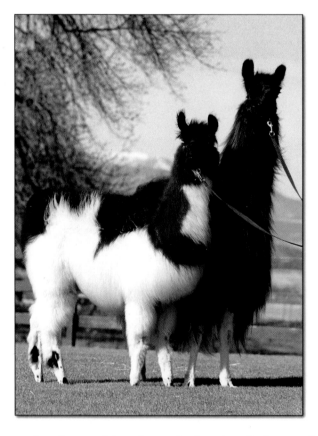

To set up a formal shoot, you need a handler to get the animal into a correct stance and a prop person to get the animal's attention (alert expression-ears up!).

Once your team is ready, make a careful visual check of the background, then set your exposure (see page 119). DO NOT introduce the animal into the location until you have the exposure nailed. (You will have at most, ten minutes to get the shot and you don't want to spend any of those minutes on exposure.)

Hopefully, by now, Murphy's Law is history. Introduce the animal and *wait*, watching through the viewfinder until you see what you have roughed out on paper materialize. Oftentimes, there will be shifting, moving, jumping, kicking, pulling … and then, all of a sudden the magic moment arrives, and you, because of careful planning, are totally ready to capture it.

▲ Step-by-Step Instructions to Meter for Correct *Animal* Color (Advanced)

Remember, with an animal portrait, you don't care about all the colors in the scene, you only care about the color of the animal and/or people.

Off-Lead Outside:

1. Set your command dial to manual and choose a shutter speed of 1/250 of a second. (See page 81.)

2. Go up to the animal *in the same light as the light for the photo,* and fill the viewfinder with the animal's color.

3. Adjust the aperture/shutter speed combination to achieve a correct exposure for that color. (You are not concerned with the total amount of light in the scene, only the light falling on the subject of your photo.) In the photo below, the photographer metered on the skin tones of the girl, then metered the horse, and chose an exposure for in-between.

4. Remember, your starting point is the shutter speed of 1/250 of a second. When you adjust the combination, you can set a higher shutter speed (not lower). If you can't get enough speed, change the ISO to a higher speed. (See page 86.)

5. Click off some test shots and study the results on your LCD screen to see if you have a good exposure. If not, make adjustments and try again.

6. Once your exposure is nailed, wait for the shot. Shoot! Have fun!

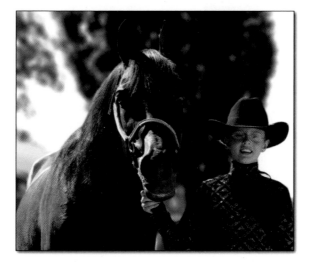

On Lead Outside:

1. Check out the light on your shooting location and decide if it is right for the shoot. (Chapter 5.) If so, follow steps 1 through 4 for an off-lead image.

2. Get into position and have your prop person move into position behind you.

3. Have the handler introduce the animal and move it into a correct stance.

4. Once the animal is standing correctly, both you and the prop person will be ready. Shoot! Have fun!

Don't pose an animal with both rear legs together. It will look as if the animal only has one rear leg.

The correct side stance. Notice that the back leg furthest from the camera is forward to achieve a balanced look.

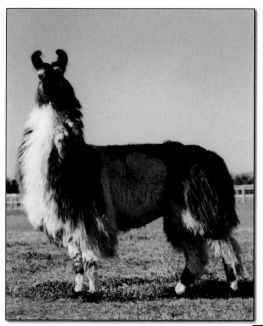

Be careful the animal is not stretched out too far.

Be sure the ground is level. Don't pose an animal "going downhill."

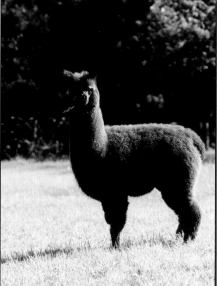

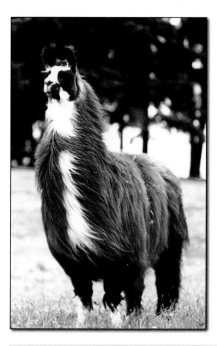

Be sure the topline of the back is straight. The animal needs to be standing with weight on all four feet to achieve a straight back line.

Rules Are Made To Be Broken!

©Marsha Hobert

Working at a show location, the photographer did such a good job capturing
the personality of this Papillon that the busy background just fades away.

Appendix A

SAVING AND PRINTING DIGITAL FILES

Saving Files:

For quality images, photographers save files in RAW, a file format where the camera does not change the image *in any way*.

When they open their Raw files with Photoshop, the first thing they do is create a master copy by saving the files in TIFF. TIFF is a file format that is lossless, meaning no information is lost by compressing the file for saving. Lossless guarantees that you can always read back exactly what you thought you saved, bit-for-bit identical, without image corruption. This is a critical factor for archiving master copies of important images.

The other option is to save the files in JPG. JPG is a file format that is "lossy," meaning that information is squeezed by compressing when the file is saved. That means that to make smaller file sizes (which is the whole point of the JPG format), some data is thrown away.

Remember that every time you save any file as a JPG, you lose 10 to 30% of its information. But it gets worse. If you open up a JPG, edit it, then save it back to a JPG, *an additional* 10 to 30% of the information is lost. Do this 5 or 6 times and you will no longer recognize the pixel soup you have created. Your photo will be RUINED.

Advantages of TIFF: No loss of the original information that is stored on your memory card when you take the photo.

Disadvantages of TIFF: The huge files require huge storage capacity on your computer and/or lots of backup on a MSD.

Advantages of JPG: The file size takes up a lot less room on your computer.

File Printing: What You Need To Know

Digital cameras make images based on pixels. Printers make images based on dots. During the printing process, the printer takes the electronic file and converts the PPI (pixels per inch) into DPI (dots per inch). So the printer measures the image in DPI not PPI. This means that the PPI in your camera does not equal the DPI in the printer. They are two separate things.

For good quality printing, you need to buy the best printer you can afford but don't go overboard—new printers will be on the market momentarily. Be sure to factor in the cost of ink.

If you already own a printer, check your owner's manual or on-line help to get the most out of it. Initially, the printer will choose the DPI, so start with that setting and see how you like the results. If you are unhappy with your prints, keep choosing slightly higher DPI settings until you are satisfied with the quality. Most printers will produce an optimal print at somewhere between 240 and 300 DPI, so going any higher than this is usually a waste of time and ink.

Every printer will express the print quality by the use of two numbers, for instance, 4800 x 1200 DPI. This is how many dots per square inch a printer can lay down at its highest setting or resolution. The larger number expresses the number of dots the printer lays down horizontally within a square inch. The smaller number indicates how many dots your printer lays down vertically within that square inch.

Resolution is measured by the DPI (dots per inch) which indicates the maximum number of dots that a laser or inkjet printer can print in a square inch. (As stated above, the PPI in your camera does not equal DPI with your printer; they are not equivalent.)

Always try to crop your images in the camera. When you crop your images with your computer software, the tighter the crop, the less print quality. You are throwing out pixels, so there are fewer pixels (less information) to fill the same amount of space (print size).

If you don't want to print your images at home, you can always upload your files to an on-line photofinisher. They can also make albums for you that you can share with friends.

You can also edit and improve your photos on-line. Two of the top companies are www.shutterfly.com and www.snapfish.com, but there are many others, so surf the web and find the one that's best for you.

Answer to the question on page 113. While the photographer was successful in capturing the personality of this Great Dane, the focus should be on the eyes and not the nose.

Appendix B

WEB SOURCES FOR PHOTOGRAPHERS

Digital Sites:

www.dpreview.com
www.stevesdigicam.com

Equipment Sites:

www.keh.com (used equipment site)
www.photoalley.com (great "compare cameras" site)
www.bhphotovideo.com
www.mycamera.com (great everything site)
www.adoramacamera.com
www.panasonic.com
www.usa.canon.com
www.nikonusa.com
www.sony.com

Learning Sites:

www.nyip.com
www.shortcourses.com
www.kodak.com

Printing:

www.snapfish.com
www.shutterfly.com
www.walgreens.com/photo
www.kodakgallery.com

Keep checking my web site WWW.SUSANLEYPHOTOGRAPHY.COM for the latest information on digital animal photography.

Appendix C

BIBLIOGRAPHY

Books, magazines and the web are wonderful sources for learning about general photography, so keep checking on-line to find the latest publications.

Binder, Jenni. *The Kids Guide To Digital Photography*. New York. Lark Books, 2004.

Darlow, Andrew. *Pet Photography 101: Tips For Taking Better Photos of Your Dog or Cat*. Oxford OX2 8DP, UK. Elsevier, 2010.

Jones, Frederic. *Digital Photography: Just The Steps For Dummies*. New Jersey: Wiley Publishing, Inc., 2005.

Karlins, David and Timacheff, Serge. *Digital Sports Photography: Take Winning Shots Every Time*. New Jersey. Wiley Publishing, Inc., 2005.

Kelby, Scott. *The Digital Photography Handbook*. Peachpit Press, 2007.

Long, Ben. *Complete Digital Photography 3nd Edition*. Hingham: Charles River Media, Inc., 2005.

Miotke, Jim. *The Better Photo Guide to Digital Photography*. New York. Amphoto Books, 2005.

Walker, Paul. *Pet Photography Now!* New York: Lark Books, 2008.

Wignall, Jeff. *The Joy of Digital Photography*. New York. Lark Books, 2006.

Aperture: The adjustable lens opening that controls how much light enters the camera.

Aperture Priority (or mode): The camera automatically calculates shutter speed after you choose the aperture.

Autoexposure: The camera automatically sets the aperture and/or the shutter speed depending on the light.

Autoflash: The camera's automated flash mode. (The camera's flash sensor reads the amount of light hitting the subject and chooses the amount of light to add.)

Autofocus: The camera automatically focuses on what it thinks is the main subject, as opposed to manual focus where you have to set the focus yourself.

Autofocus Lock: A function that allows you to hold the focus on a selected subject while you move the camera to recompose the image.

Back Light: The light source is in front of you (outside, it is the sun), and behind your subjects, lighting them from behind.

Camera Shake: Camera movement as the shutter button is pressed, resulting in blurry photographs.

Candid Image: An unplanned photograph as opposed to a staged portrait.

CCD (charge-coupled device): The chip which records the image in a digital camera; the sensor.

CMOS (complementary metal oxide semiconductor): The chip which records the image in a digital camera; the sensor.

Composition: An art term for how a picture is designed.

Compression: A way of reducing a digital picture file.

Contrast: The difference in tone between the bright and dark areas of a photograph.

Cropping: Recomposing an image by cutting off its edges. This can be done in the camera by changing your position, or later with your computer and software program.

Delete: Permanently erase a picture file.

Depth of Field (DOF): The range (from front to back) in an image that remains sharp. Shallow depth of field means only a limited area is in focus. Deep depth of field means everything in the picture looks sharp.

Download: To transfer pictures from your camera to your computer or from the internet to your computer.

DPI (dots per inch): A measurement that defines the number of dots in a print.

Exposure: The amount of light that is allowed to hit the sensor. Too much light will cause an overexposed (too bright) image. Too little light will cause an underexposed (too dark) image. Balance between light and dark is the key to a good exposure.

File Size: How much memory space a digital picture file takes to store in a camera's memory. High resolution pictures have a bigger file size than low resolution pictures.

Fill Flash: A flash mode that fires the camera's built-in or accessory flash to add some front lighting to the shadow areas of the subject.

Focal Length: A measurement of the magnifying power of a lens. A 50mm lens has a focal length of 50mm and sees things at roughly the same size as the unaided human eye. A 400mm telephoto focal length lens is like a telescope. A 20mm wide-angle lens opens a wider field of view.

Front Lighting: The light source (the sun, if you are outside) is behind you and in front of your subjects, lighting them from their front.

f-stop: The numbers used to indicate the size of the aperture (the adjustable opening in a lens). The size of the opening combined with the shutter speed and the ISO serves to expose each photo with the correct amount of light.

ISO: The abbreviation for the International Standards Organization. The standard is based on light-sensitivity ratings. With digital, it refers

to how sensitive the CCD or CMOS is to light. The lower the ISO, the lower the sensitivity to light; the higher the ISO, the higher the sensor's sensitivity is to light.

Isolated Focus: Shallow depth of field, when one object is in focus while the other areas in both the foreground and background, are out of focus.

JPG (or JPEG): A picture format that is used for digital photos.

LCD (Liquid Crystal Display): A monitor on a digital camera that allows you to review images immediately after shooting them or allows you, on some cameras, to view the photo before it is taken.

Lens Hood: A device used on the end of a lens to block the sun or other light source in order to prevent glare from falling on the image.

Manual Focus: The camera function that allows the photographer to adjust the focus. (As opposed to autofocus where the camera automatically does the focusing.)

Megabyte (MB): A measurement of file size. The higher the MB rating, the higher the resolution of the photo.

Megapixel: 1,000,000 pixels. Often used to indicate the resolution of a camera.

Memory Cards: Removable storage onto which your camera records picture files. They can be erased and used over and over again. Cards with more MB (megabytes) can hold more picture files before they are full.

MSD: Mass Storage Device. A device used to store large amounts of data (digital photos). MSDs include: hard disk drives, optical drives (CDs and DVDs) and various flash drives.

Noise: Texture (in an image) that is made up of tiny dots. A noisy image looks fuzzy, grainy and dull. This is a side effect of using fast ISOs and is especially noticeable in extreme photo enlargements.

Optical Viewfinder: The little window you look through when taking a picture, usually located at the top center of the back of the camera.

Overexposure: When an image looks too bright.

Panning: A camera technique used to give your images a feeling of movement.

Pixel: A single picture element that, when combined with others, creates a digital photograph.

Point-and-Shoot Camera: A fully automatic, or semiautomatic digital camera. Usually more compact than a digital SLR.

Polarizer: A filter used on the end of a lens to help enhance outdoor images by increasing contrast and color saturation, eliminating reflections from glass and water and darkening the sky.

PPI (Pixels Per Inch): A way to state a picture's resolution in terms of how densely the pixels are packed (for example, there are 300 per inch, or 300 ppi).

Red-Eye: The red glare effect in a subject's eyes; can be reduced or eliminated with pre-flash.

Resolution: An expression of how many pixels make up a digital image. More pixels (higher resolution) means more quality but larger file sizes.

Rule of Thirds: A compositional rule of thumb that states that an image should be divided into nine equal parts by two equally spaced horizontal lines and two equally spaced vertical lines and that important compositional elements should be placed along these lines or their intersections.

Sharpness: The degree of clarity and crispness in an image.

Shutter: The mechanism that opens and closes to control how much light is allowed into the camera.

Shutter Button: The button you press to take the picture. It operates the shutter.

Shutter Priority: The mode that automatically calculates aperture after you choose the shutter speed.

Shutter Speed: The amount of time the shutter stays open (letting light into the picture). Slow speeds allow more light into the camera, and fast speeds allow less light into the camera.

Side Light: Light from the side, illuminating one side of the subject while the other side is in shadow.

Skylight Filter: A filter used on the end of a lens that reduces the haze and blue color cast in scenic images. It is not necessary with digital close up images, (digital CCD chips do not record haze and blue color casts the way color film does) but it always serves an important function for lens protection.

SLR Camera: A single-lens reflex camera, that has interchangeable lenses and advanced accessories.

Soft: Term used to refer to photographs that are slightly blurry and out of focus.

Telephoto Lens: A lens that magnifies, enabling you to take pictures of things that are very far away. Telephoto lenses usually have a focal length of 80mm or above.

TIFF: A picture file format used mostly by professionals.

Underexposure: When an image looks too dark.

UV (Ultra Violet) Filter: A filter used on the end of a lens that reduces the haze and blue color cast in sceinc images. It is not necessary with digital close up images because digital CCD chips do not record UV waves the way color film does. Most lenses today are already UV coated to prevent haze and blue color casts.

Viewfinder: A viewing window that you bring up to your eye and look through to compose pictures.

White Balance: The camera settings used to correct color shifts in an image that occur in different kinds of light. The white balance setting can be set by either the camera or the photographer, depending on the camera model.

Wide-Angle Lens: A lens that gives a wide, expansive view of a scene. Because more of the scene is included in the picture, objects may look smaller through such a lens than they do in real life.

Zoom Lens: A type of lens that allows you to zoom from a wide view of the scene to a closer look at your subject. It gives you more flexibility by allowing you to easily change the amount of magnification just before you shoot.

INDEX

Depth of Field, 62, 75-78, 81, 91-95, 130
Diffused light, 19
Digital cameras, 6, 7, 15, 24, 42, 106, 125, 127
Digital film, 7
Disney, Walt, 5
Download, 130
DPI (Dots Per Inch), 125, 126, 130
Ears back, 99-100
Edison, Thomas, 15
Editing, 15, 97-103
Eighteen percent gray, 69-71
Eliot, George, 17
Emerson, Ralph Waldo, 83
Equipment, 5-13, 127
Exposure, 65-81, 110, 112, 118-119, 122, 130
External flash, 9, 114
File formats, 125
File size, 23-28, 125, 130
File storage, 25, 125
Fill flash, 111-112, 130
Flash, 9, 14, 20, 21, 79, 109-114, 122
Focus, 37-46, 64, 87-89, 93, 97
Formal image, 58-59, 115, 118-122
Freezing Action, 69, 76-77, 81-84
Front lighting, 18, 111, 130
F-stop, 75-77, 85, 86, 91-96, 130
Glossary, 129-133
Goethe, Johann Wolfgang van, 3
Grooming, 54, 63, 116
Holding the camera, 29-32
Image size for use, 23
Inside photo, 61, 79, 114, 122-123
ISO speed, 9, 73, 75, 86-87, 95, 109-114, 119, 131
Isolated focus, 14, 85, 92-94, 96, 131
JPG, 125, 131
Lange, Dorotha, 39
LCD screen, 20, 32, 35-38, 48, 106, 114, 119, 131

MEET SUSAN LEY

A professional animal photographer for over 35 years, Susan Ley began her career on a Kentucky llama farm when she picked up a camera and resolved to capture her unique animals on film.

She has written and photographed two books, *Llamas; Woolly, Winsome and Wonderful* and *Photoshop For Lamas.* You can find her articles and photographs in countless magazines, books and calendars.

Pet Photography For Fun is the fulfillment of Susan's dream to translate the technical aspects of good animal photography into a fun, easy to use manual for amateurs.

Susan lives in Key Largo, Florida where she enjoys the turquoise waters with her family and her Irish Terrier, Morgan. She is currently working on a photography book featuring boat dogs and their adventures on the water.

Visit www.susanleyphotography.com for more information.

MEET MARSHA HOBERT

Marsha has always had a love for photography. She is rarely without her camera – taking photographs at events and in the Colorado mountains. She has a great passion for cats and has taken thousands of pictures of her Siamese, several shown in this project.

She lives in Estes Park, Colorado, gateway to Rocky Mountain National Park with her husband Ken and eight Siamese cats. Together they own and operate Hobert, Ltd. providing complete business services, graphic design, printing, and photography.

Visit www.photosbymarsha.com to see more of her photographs.